IMAGES
of America

LITTLE CITIES OF BLACK DIAMONDS

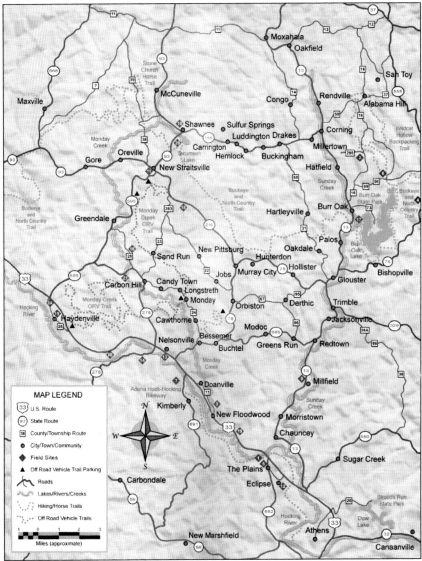

This map shows most of the coal-mining communities known as the Little Cities of Black Diamonds and the roads and highways that connect them. At this scale, however, the runs, creeks, hollows, and ridges of the area's distinctive landscape cannot be seen, nor can the back roads and the abandoned railroad beds that once transported the region's mineral wealth. Many villages and hamlets have passed from the scene, but others remain, home to descendants of the hardworking and resourceful people who built the more than 70 communities of the Little Cities. (Chad Seurkamp, Little Cities of Black Diamonds Council.)

On the cover: The open-flame lanterns on the miners' soft caps seen in this late-19th- or early-20th-century photograph indicate that East Side Mine No. 9 had not received the latest in mining and safety equipment. Located in Salt Lick Township, Perry County, this mine was near the village of Carrington and was one of many in the region owned by the Sunday Creek Coal Company. The mine closed in 1931. (Wesley E. Tharp collection and William E. Dunlap collection.)

IMAGES of America

LITTLE CITIES OF BLACK DIAMONDS

Jeffrey T. Darbee and Nancy A. Recchie

Copyright © 2009 by Jeffrey T. Darbee and Nancy A. Recchie
ISBN 978-0-7385-6041-0

Published by Arcadia Publishing
Charleston, South Carolina

Printed in the United States of America

Library of Congress Control Number: 2009926225

For all general information contact Arcadia Publishing at:
Telephone 843-853-2070
Fax 843-853-0044
E-mail sales@arcadiapublishing.com
For customer service and orders:
Toll-Free 1-888-313-2665

Visit us on the Internet at www.arcadiapublishing.com

This book is for the dedicated individuals and organizations that are proud of their heritage and are working to preserve the stories, the places, and the memories of the Little Cities of Black Diamonds.

Contents

Acknowledgments		6
Introduction		7
1.	The Hocking Valley Coalfield	9
2.	The Railroad Era	19
3.	Coalfield Communities	41
4.	Life and Work in the Little Cities	65
5.	After the Coal Boom	95
6.	The Little Cities of Black Diamonds Today	119

ACKNOWLEDGMENTS

There is always a team behind the author that does a lot of the work that precedes writing a book, and without these people there would be no book. The author is only the tail end of the process. My thanks go first to my wife, Nancy A. Recchie, and our son, James Darbee, who helped with scanning, reviewing, organizing, and numbering the wonderful images. Nancy also gave me good advice on corrections and revisions of the text and captions.

Dedicated citizens of the Little Cities region also were invaluable helpers who found images, sorted out facts, provided details, suggested ideas, and reviewed text and captions. I could not have done the writing without the always-willing assistance of John Winnenberg, Little Cities of Black Diamonds Council; Cheryl Blosser, Little Cities of Black Diamonds Council and New Straitsville History Group; Nyla Vollmer, Haydenville Preservation Committee; Lorinda LeClain, Nelsonville Public Library; and Ann Cramer and Chris Euler, Wayne National Forest.

Images in this volume were provided courtesy of the following: Little Cities of Black Diamonds Archive (LCBDA); New Straitsville History Group (NSHG); Wesley E. Tharp collection and William E. Dunlap collection (WED); Buhla Collection MSS 113, Mahn Center for Archives and Special Collections, Ohio University Libraries (OU); Haydenville Preservation Committee (HPC); Andrew Bashaw (AB); Paul Moore collection (PM); Nelsonville Public Library (NPL); Nancy A. Recchie (NAR); Cecilia Rinaldi (CR); the collection of Jack Shuttleworth (JS); Wayne National Forest (WNF); and the John Mingus family through Susan J. Mingus (SM).

Credit also must go to the *Athens Messenger*. In the 1890s, that newspaper coined the term "Little City of Black Diamonds" in reference to Nelsonville, from which so many millions of tons of coal were shipped over the years. In the 1970s, the name was resurrected and applied to all the region's coal communities by Ivan M. Tribe in his pioneering studies of the development of the region and the lives and work of the people there.

And finally, my thanks to Melissa Basilone, senior acquisitions editor at Arcadia Publishing, for her advice, encouragement, and patience.

—Jeffrey T. Darbee

INTRODUCTION

Southeastern Ohio never was covered by the continental glaciers of prehistoric times. As a result, it is a region of narrow valleys and high hills, with creeks and runs that rush from steeply pitched watersheds that form the western foothills of the Appalachian Mountains. Agriculture in this region always was difficult due to the general lack of level, arable land, but what lay hidden below the ground would prove to be of much greater value than anything that could be grown upon it. Nature endowed this part of the Buckeye State with vast mineral riches—coal, clay, oil, and natural gas—that would produce great wealth, at least for those who owned the mineral rights. Coal, in particular, was abundant, lying in great veins 5, 8, or sometimes more than 10 feet thick. Development of these resources in the late 19th and early 20th centuries would launch a half-century-long boom, the visible signs of which last to this day.

Between 1870 and 1920, four counties in the Appalachian region of southeastern Ohio were at the center of the Buckeye State's coal production. By the early 20th century, this region had more than 70 mining communities large and small, which became known as the Little Cities of Black Diamonds. Developed primarily to serve coal miners and their families, some were company towns, owned completely by the coal companies; others were speculative real estate developments begun by promoters who saw the coal boom coming. As time went on, the area gained a distinctive character and sense of place that arose from its severe topography, its resilient people, and its unique architecture. Made up of the southern part of Perry County, the eastern part of Hocking County, the northern part of Athens County, and the western edge of Morgan County, the Little Cities region measured about 15 miles square.

Transportation was the key to the region's development. Coal had been discovered early in the 19th century, but it sold only in local markets until the Hocking Canal opened in 1843 between Columbus and Athens. The canal had a direct route to Columbus and led to a great increase in coal production, but the winter freeze stopped traffic for several months each year. It was not until the arrival of the Columbus and Hocking Valley Railroad, which reached the region in 1869 and was completed to Athens in 1870, that the stage was set for intensive development of the resources in the Little Cities region. Customarily called the Hocking Valley, the railroad connected the region to Columbus and to the rest of the nation, and rapid development of the area called the Hocking Valley Coalfield soon followed.

Coal companies large and small laid claim to mineral rights throughout the region, following the growing network of branch lines that extended from the Hocking Valley and, later, predecessors of the Baltimore and Ohio and the New York Central Railroads. Some communities, including Logan on the north, Nelsonville to the west, and Athens on the south, predated the coal boom

and had diversified economies. However, most of the Little Cities sprang up as the railroads' branch lines penetrated valleys and hollows to reach new coal deposits. Most were small, ranging from a few hundred to perhaps 2,000 residents, and they relied almost entirely on the coal industry for their employment base and on the miners for economic activity.

These communities had some typical development patterns. Some were owned by the coal companies and had rows of similar homes clustered near the company store, school, and church; outside retailers and enterprises such as saloons typically could not locate in these communities.

Most of the Little Cities, however, were real estate ventures developed by people who bought land to plat and sell lots. These communities tended to have a single main street along which various businesses located; homes, churches, and schools occupied nearby lots, often on surrounding hillsides. Typically the railroad depot, the funnel through which nearly all the economic life of the town flowed, was in a central location. Distinctive architecture developed in the Little Cities, with the overhanging porch the dominant feature. It was common for commercial buildings to have apartments above them, with a second-story porch supported by decorative brackets. Some of these buildings survive today and are unique to this area.

Coal was a boom-and-bust business, which led to considerable conflict between the mine operators and their workers. Communities such as Shawnee and New Straitsville were the locations of important events in the American labor movement. Labor leaders such as Christopher Evans had a long association with the region, and sites such as the Knights of Labor hall in Shawnee and Robinson's Cave in New Straitsville remain today as reminders of the era. Events here led directly to the founding of the United Mine Workers of America.

By around 1920, the mines that gave life to the area began to play out, and the development of strip mines elsewhere in the country put the deep mines of the Little Cities at a competitive disadvantage. The 50-year coal boom of the region collapsed quickly, and mining today is only a shadow of what it once was. The Little Cities communities fell into a long, slow period of decline as businesses closed and people moved away, but over the last 30 years, there has been a rebirth of appreciation for the region's heritage and natural beauty. It has unique cultural resources and nationally significant architecture that tells a story at least as compelling as that of other better-known mining regions. Through Web sites, publications, conferences, organized tours, dramatic readings, reenactments, and word of mouth, heritage tourists are increasingly aware of the Little Cities and of what they can learn about its people, its places, and its traditions.

A new economy based on celebration of the Little Cities' heritage continues to grow in the capable hands of dedicated residents, most of them natives of the area, joined by former residents who moved away but have returned home in retirement. They have accomplished remarkable things with minimal resources and plan to keep on doing so, to keep the Little Cities' rich heritage from being lost. They welcome all who wish to come to see and learn.

One
THE HOCKING VALLEY COALFIELD

The Little Cities of Black Diamonds are located in the physiographic section of Ohio known as the unglaciated plateau. Lying to the north and east of the Hocking River, the Little Cities region is centered on the valleys of Sunday Creek and, to its west, Monday Creek. Said to have been named for the days on which early settlers discovered them, these creeks and their tributaries drain watersheds that lie between about 650 and 1,000 feet in elevation. The 350-foot difference between the high and low points is not great, but the short length of the area's runs and creeks has created a rugged terrain of steep-sided, narrow valleys with little fertile bottomland.

The bedrock under this region was from the ancient time known as the Pennsylvanian, a period when most of the coal deposits formed in the eastern United States. In this part of Ohio, the Pennsylvanian rocks were about 800 feet thick and contained two distinct formations, which together had about three dozen coal veins of varying thickness and quality. Some of these veins had exposed edges along the sides of valleys, making them easy to mine; others were deeper and harder to find, requiring shafts and hoisting equipment.

Settlers knew of the area's coal deposits by the 19th century, but it was not until railroads penetrated the hills after the Civil War that coal mining rapidly developed. There were other valuable resources such as clay, natural gas, and oil, but coal mining was king. It shaped the landscape, influenced the development of communities, and was woven into the life of every citizen.

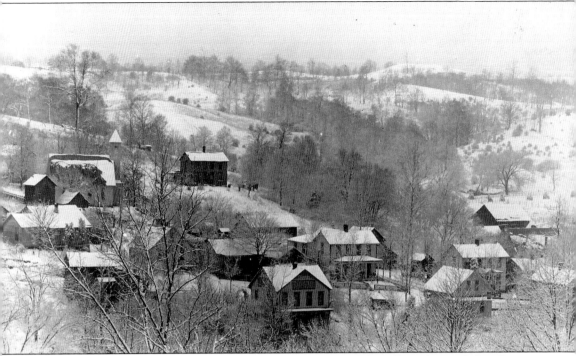

A fresh layer of snow has etched the buildings, the trees, and the hills in sharp relief in this view of the village of Hemlock. Photographer John Bieseman noted that he took this photograph at 11:15 a.m. on December 28, 1915, with an exposure time of eight seconds at an aperture of f/64. The view looks south from the hill above the north side of town and shows the essential character of the communities called the Little Cities of Black Diamonds: a small cluster of homes and businesses, a prominent church, and the high hills and deep ravines under which the seemingly endless veins of coal awaited the miner's pick. Bieseman wrote on the back of the photograph, "I have rambled over all these hills picking berries, hunting squirrel, etc. Had some good times." (WED.)

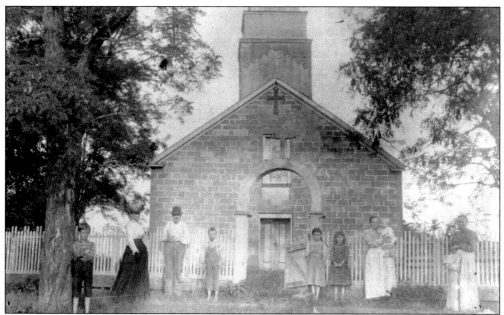

Southeastern Ohio had some of the earliest settlements in Ohio, but many people arriving from elsewhere simply moved through the region due to the limited amount of good agricultural land. By 1830, for example, Logan in Hocking County had only 322 citizens, even though it had been settled in 1816. Athens had a population of only 728 and was the largest community in the area. As time went on, more settlers arrived and began to establish the institutions of permanent communities. Churches were among the earliest to be built. The simple stone church in the photograph above is the Catholic church at Chapel Hill, a very small community about three miles northeast of Corning in Perry County. The photograph below shows the 1854 brick church known as the original St. Pius South Fork Chapel near Moxahala in Perry County. (Above, LCBDA; below, NSHG.)

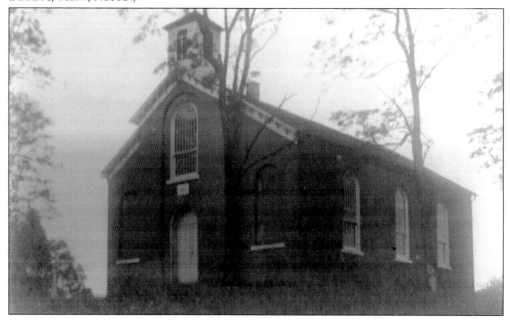

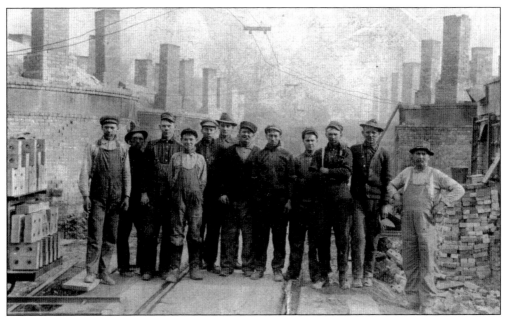

The brick plant at New Straitsville, at the far south edge of Perry County, drew its raw material from the extensive clay and shale deposits lying close to the coal veins. This view from the early 20th century shows the distinctive domed round kilns and tall square smokestacks typical of the numerous brick plants in the Little Cities region. Products included drainage tiles, sewer pipe, chimney pots, and millions of paving bricks. (NSHG.)

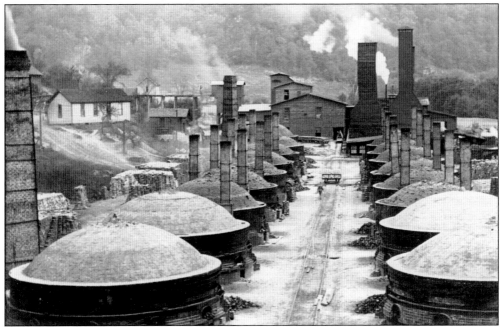

The brick plant at Trimble, just south of Glouster in Athens County on State Route 13, was similar to the one at New Straitsville and to many others in nearby communities. Manufacturing of clay products did not employ as many people as coal mining, but it was a major industry in the region. (OU.)

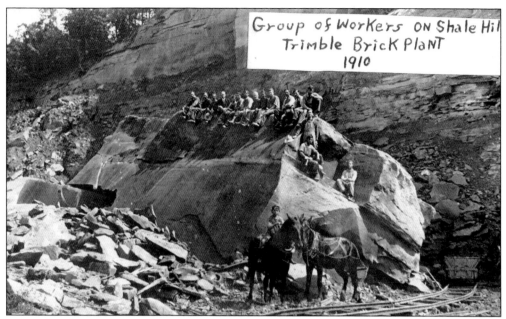

A lot of rock and soil has to be moved before coal or clay can be loaded up for processing. In comparison to today's largely mechanized economy, it is easy to forget the monumental amounts of human (and animal) labor required in the past to keep industrial processes going. These views show the gathering of raw material for the brick plant at Trimble. Working on Shale Hill near the plant, employees in the photograph above have paused in their labors. When the small mine car at the right was full, animal power moved it to the head house in the photograph below. In this view, two workers pose with a loaded car. At the extreme right, the steel cable and the abrupt drop in the narrow-gauge track indicate that the loaded cars were lowered by cable along an incline railway to the valley below. (OU.)

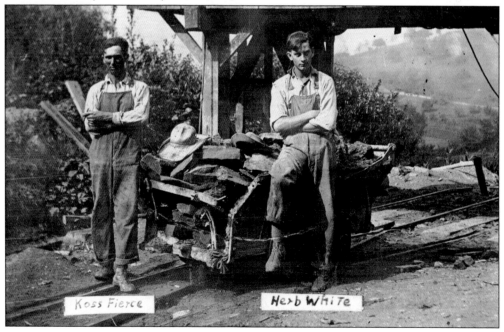

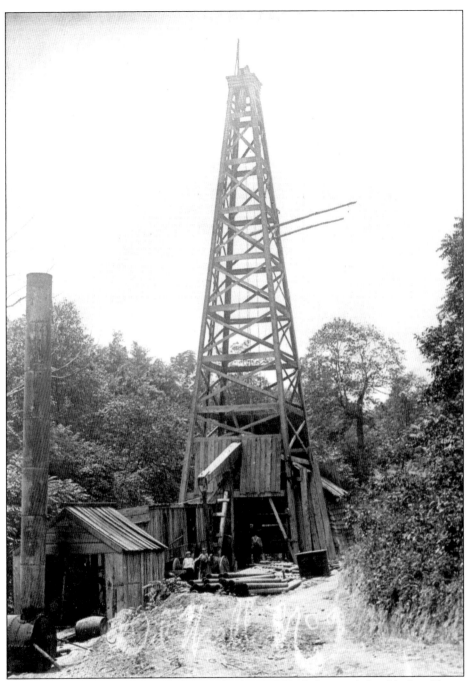

The Hocking Valley Coalfield yielded not only clay and black diamonds but black gold as well. This rig stood near the village of Ludington, just west of Hemlock and about two miles east of Shawnee. The tall stack at left served the horizontal outdoor boiler. Steam from the boiler was piped into the small shed, which protected a stationary steam engine from the weather. The engine, in turn, ran a leather belt that transmitted power to a crank on the pumping rig, giving the beam the up-and-down motion that raised the oil to the surface. There was no need to run electric lines to this remote location. (LCBDA.)

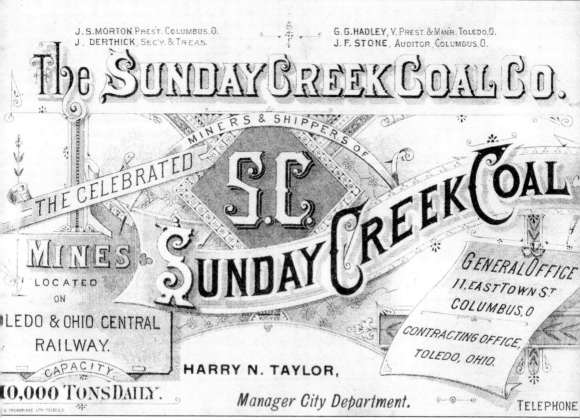

Coal mines of all sizes penetrated the hills of the Little Cities region. There were some independent miners, but it was not very long before the area was dominated by large operators controlling many mines. The Sunday Creek Coal Company was one of the largest. This firm had elaborate letterhead typical of the late 19th and early 20th centuries. (WED.)

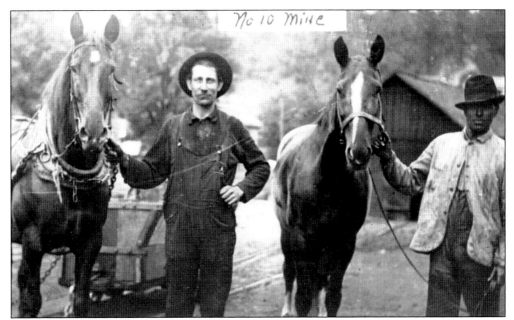

Before the advent of electrically powered mine locomotives, muscle power rolled loaded mine cars out of the mine and to the tipple for processing and shipping. Sometimes the muscles were human, but more often they were animal, typically horses and mules. Some mines were even known to use dogs to pull the cars, particularly when the mine ceiling was too low for a horse or a standing man. (OU.)

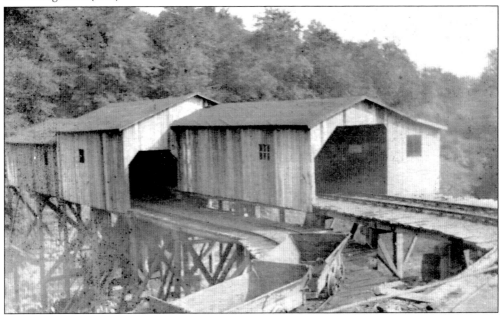

The mining, processing, and shipping of coal was a messy business. Piles of waste rock (known as gob), broken machinery, railroad tracks, dirt roads, abandoned buildings, and gashes in the landscape from strip mining left their marks on the region. This modest tipple, probably from the early 20th century, is an example of a smaller mining operation that did not scar the land very much. The small four-wheeled mine cars await a return run to the mine for a new load. (NSHG.)

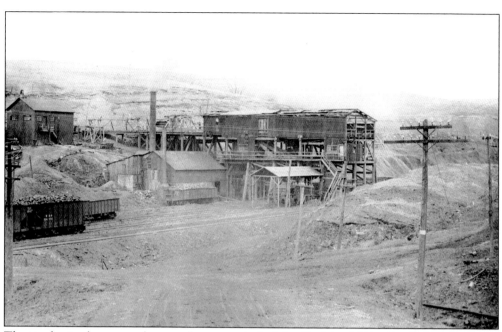

The tipples in these two photographs are typical of the Hocking Valley Coalfield in both size and construction. Built with a heavy timber frame and wood plank siding, these structures had no frills or decoration and were purely utilitarian. Raw coal in small mine cars entered one end of the tipple, from the left in the photograph above and from the right in the photograph below. Inside the tipple, the coal was cleaned of any waste rock and sorted into various sizes through perforated metal screens. Chutes then delivered the coal to waiting railroad cars. The tipple in the photograph above has been identified only as B&O mine No. 3 in Perry County; in the photograph below is mine No. 5 in Murray City, in the far eastern end of Hocking County. The stark landscape immediately around these structures shows the impact coal mining typically had on the environment. (Above, OU; below, NPL.)

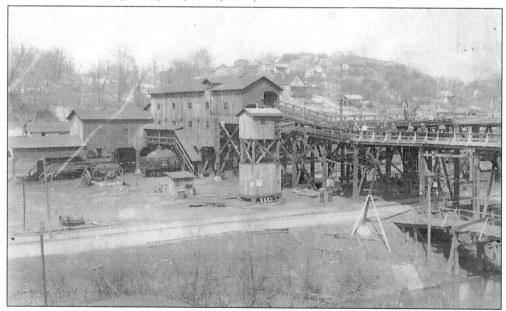

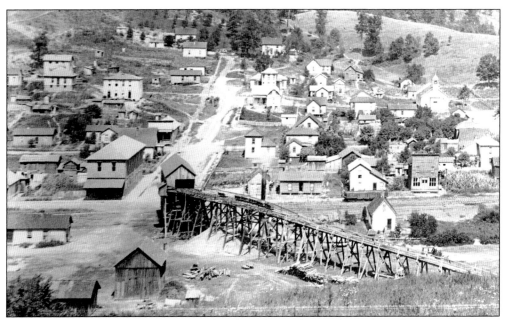

A coal mine was opened near a vein of coal, and a tipple was located on the nearest railroad line. Many times mines and tipples were built right in the middle of a community. In the case of Glouster, shown in this early-1900s view, the town grew up around an existing mine. This is the Palmer Mine, which predated the founding of Glouster and operated between 1877 and 1907. (OU.)

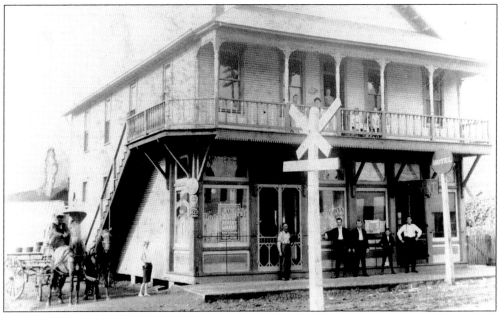

This is the Hogan and Murphy Saloon in Murray City. Built entirely of wood, it is typical of the quickly built, style-conscious structures that popped up in the late 19th century. It was commercial downstairs and residential, with a hotel in this case, upstairs. Exterior stairs led to the second floor. The unique, bracket-supported overhanging porches were found in quantity only in the Little Cities of Black Diamonds. (OU.)

Two

THE RAILROAD ERA

The Little Cities of Black Diamonds and the railroads that connected them went hand in hand; neither could thrive without the other. It is no exaggeration to say that without the railroads the region would have developed much more slowly than it did.

The Hocking Canal, completed in 1843 between Athens and a connection with the Ohio and Erie Canal that ran between Cleveland and Portsmouth, helped to enlarge what had been mainly a local market for Hocking Valley coal. The canal could not, however, operate year-round, and it could not penetrate the hills and valleys where much of the coal lay. Rail transportation was the key to developing the vast coal reserves, and development of the Little Cities' railroad network sparked the 50-year-long coal-mining boom that came to define the region.

Between 1870 and 1900, small local railroads and larger regional roads built main lines and branches to and through the Hocking Valley Coalfield. A changing maze of spur tracks served mines when they opened and were torn up when the coal ran out. Over time, the smaller railroads became parts of three great eastern systems, the Baltimore and Ohio Railroad (B&O), the Chesapeake and Ohio Railway (C&O), and the New York Central Railroad (NYC). The B&O and C&O lines served the Monday Creek valley in the western portion of the Little Cities region, while lines of the NYC served the Sunday Creek valley.

Coal hauling was not the railroads' only service. They did carry away vast amounts of it, but they also brought in nearly all the needs of daily living—food, clothing, toys, hardware, mining equipment, washing machines. They carried passengers between local points, or to cities such as Columbus, and beyond to other parts of the country. They facilitated a steady flow of mail, telegrams, express shipments, and news of an outside world not many local residents got to see. And they provided many good-paying, steady jobs. Corning, in the Sunday Creek valley, was a railroading center where most of the town's men were railroaders. Restaurants were open all night to serve train crews and other railroad workers, and seven tracks crossed Main Street. However, as time went on and both automobile technology and paved highways developed, nearly all this traffic dried up, and the railroads disappeared almost entirely from the Little Cities region.

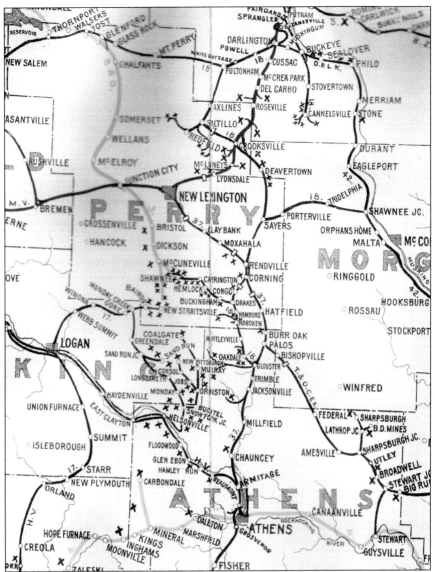

In 1900, the Ohio Commissioner of Railroads and Telegraphs published the state's annual railroad map. By this time, the network of lines serving the Little Cities was complete. The western part of the region was connected to Columbus by the Columbus and Hocking Valley Railroad (commonly called the Hocking Valley and later absorbed by the C&O), which had branches and spurs reaching north and east from Logan and Nelsonville into the watershed of Monday Creek. The many Xs show the locations of rail-served coal mines. Just north of New Straitsville, the B&O came down through McCuneville and turned east to terminate in Shawnee. To the east, in the Sunday Creek watershed, predecessors of the NYC operated the main lines, branches, and coal spurs. These included the Columbus, Shawnee and Hocking Railroad, No. 18 on the map and later the Zanesville and Western Railroad (Z&W); the Toledo and Ohio Central Railway (T&OC), No. 37, north of Corning; and the Kanawha and Michigan Railroad (K&M), No. 37, south of Corning. Chauncey and Armitage, on the south, and Shawnee, on the north, were the only points at which the Sunday Creek and Monday Creek rail networks were linked together. (Authors' collection.)

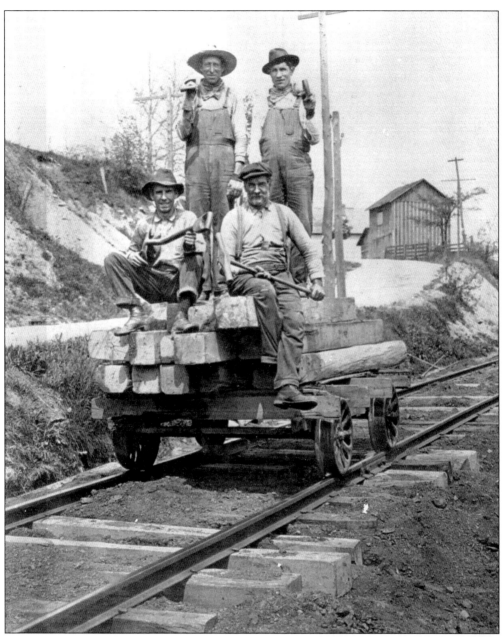

Riding high on a push car used for moving maintenance materials, a section crew of the Z&W poses for a photograph at Hemlock, on the line between Corning and Shawnee. Section crews were assigned to short segments of a railroad, usually four to seven miles long, and had to watch for broken rails, loose track spikes, washouts, rotted cross ties, and other hazards. This crew worked between Drakes and Shawnee. The undated photograph probably dates from the early 1900s, when the Z&W (known to local wags as the "Zigzag and Wobbly") ran two passenger trains a day between Shawnee and Zanesville. Standing on the left is Ed Dunlap, with John Thornton next to him. Sitting are Harl Secrest, left, and Jim Jenks. Secrest was well known locally as a banjo player and in this view seems to be trying to get some music out of his shovel. All this crew's work, including moving the push car, was entirely by hand. (WED.)

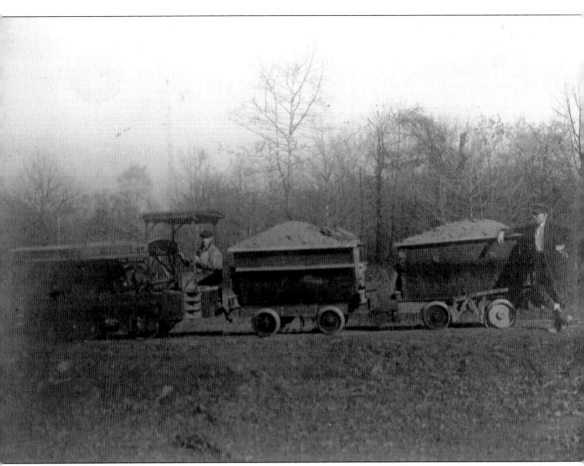

Industrial railroads were part of the transportation scene in the Little Cities. They were usually narrow gauge (the distance between the rails was less than the standard four feet, eight and a half inches) and short in length. Their purpose was to carry raw and finished materials around industrial plants, so they typically carried no passengers and were not considered "common carriers" like the large steam railroads. Earlier lines had small steam locomotives, but by the early 20th century, most industrial lines employed internal combustion power. This photograph is titled "Sand Bank, Tunnel Hill Road," and sand is indeed what appears to fill the two small dump cars. (LCBDA.)

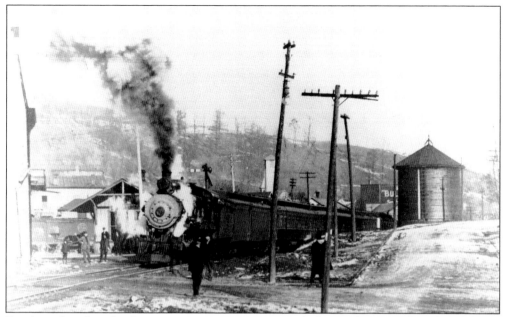

People gathered at the depot at train time, some to work (buggy drivers and mail clerks) and some just to watch (idlers and layabouts). Whatever the motivation, a K&M passenger train headed south through Glouster in the early 1900s was always a reason to stop and look. The water tank is long gone, the streets have been paved, and trees have covered the hills, but the Glouster depot still stands. (OU.)

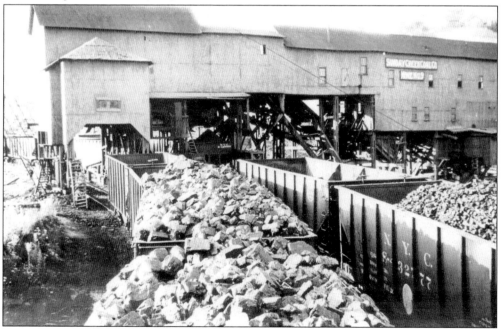

Far more important than passengers to a railroad's bottom line was freight revenue. In the Little Cities, that usually meant coal. Loaded cars at one of the Sunday Creek Coal Company's many mines attest to how important the coal traffic was and to how railroad service made coal mining economically feasible. (LCBDA.)

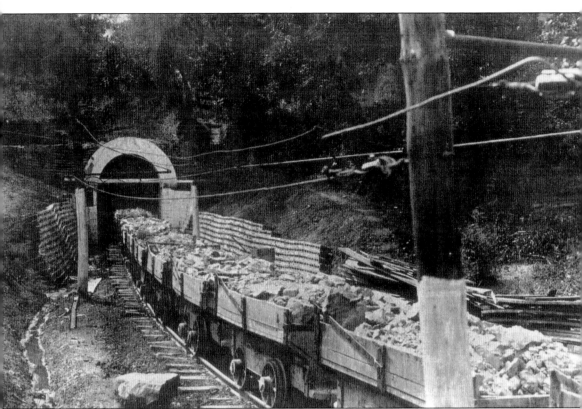

Railroad technology was critical not only in getting coal to distant markets but also in simply getting it out of the ground. Small mine cars with a capacity of a ton or two were common from the start of the coal boom in the Little Cities, but with only horses, mules, dogs, or humans to pull the cars, production stayed limited. Introduction of electrically powered mine locomotives in the late 19th century revolutionized mining and vastly increased production. The Jeffrey Manufacturing Company of Columbus was perhaps the best-known builder of powered mining equipment. (HPC.)

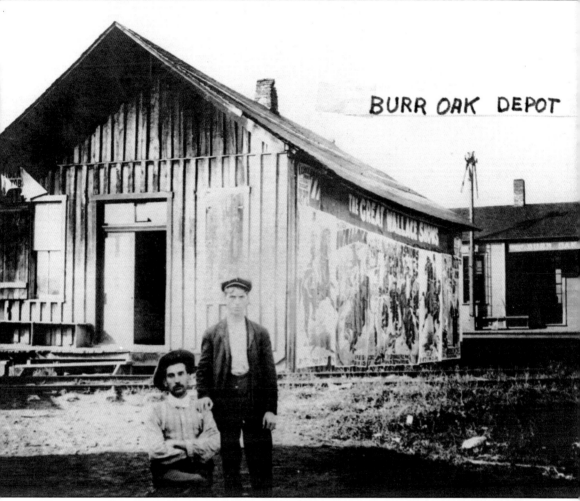

All is quiet in Burr Oak, a good time for these gentlemen to stop for a portrait. Located 4.3 miles south of Corning on the K&M, Burr Oak was a small station with limited passenger service. The K&M connected Corning with Gauley Bridge, West Virginia, east of Charleston, and later became part of the T&OC, which itself became part of the NYC. It was this cascading sequence of leases and mergers that gradually assembled the large eastern railroad systems. Here at Burr Oak, the passenger depot is in the background, while the foreground building is the freight house, its long side adorned with a poster advertising the coming of the Wallace circus. On the mast in front of the passenger depot is the order board; the station operator could raise the semaphore arms to a horizontal position to tell the engineer of an approaching train from either direction that he had to slow or stop to receive a written order or message. (OU.)

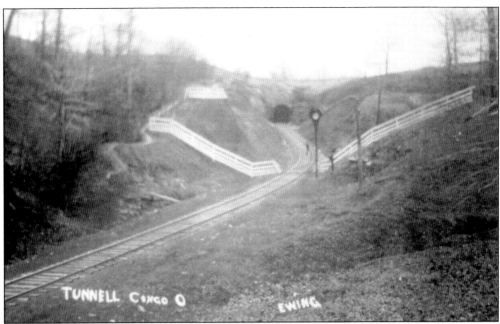

The Z&W originated at Zanesville and ran through Fultonham and Crooksville. At milepost 32, the T&OC came in from the northwest and the two railroads ran side by side another mile to Corning. At the north end of Corning, the Z&W crossed the T&OC at grade, then looped west and northwest before turning south again to Drakes and west to Shawnee. On the loop was the mining town of Congo, which sat on a ridge about two miles northwest of Corning and generated a good deal of coal traffic. The topography was too steep for the railroad to climb into Congo itself, so a tunnel was completed in 1889. The photograph above looks toward that tunnel, around the late 19th century. In the photograph below is the simple home of the tunnel caretaker, with the man of the house and his family. (LCBDA.)

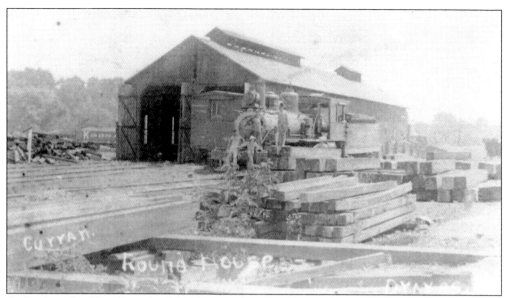

At Drakes, the West Branch of Sunday Creek created enough flat bottomland for the Z&W to build a small yard, as well as a Y-shaped junction. East of the junction, another line, shared with the K&M, ran east and south to the K&M main line at Glouster. That piece of track served mines at Oakdale and a short mining line called the Indian Run Railway. The K&M called this line the Buckingham branch, although it used the Z&W track to serve mines as far west as the area around Carrington. The photograph above shows the small Z&W engine house at Drakes, with its roof monitor to vent locomotive smoke. In the photograph below is the Z&W's substantial frame passenger depot at Drakes. The downward-pointing order board indicates no orders or messages for westbound trains, but the raised board for eastbounds means they must stop. (LCBDA.)

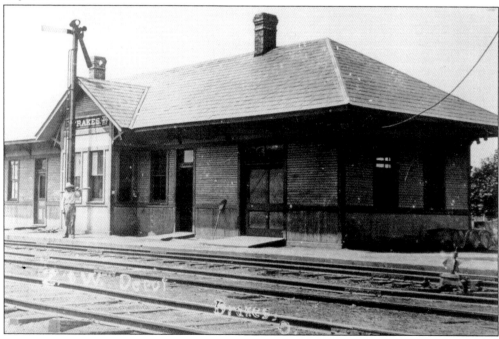

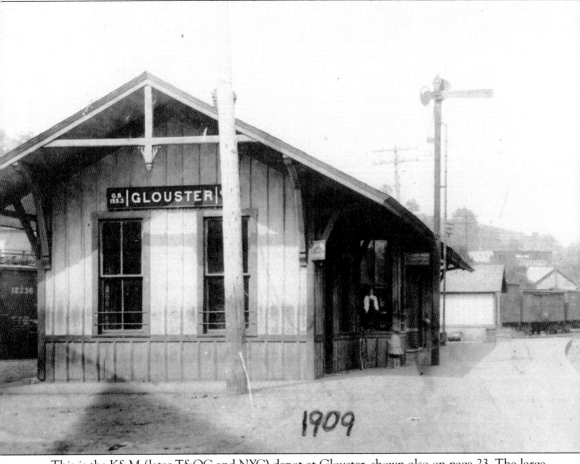

This is the K&M (later T&OC and NYC) depot at Glouster, shown also on page 23. The large windows, board-and-batten siding, and broad overhanging roof with decorative supporting brackets all are classic railroad depot design elements. Also typical is the bay window on the east side, the track side, which enabled the station agent to see approaching trains from either direction. The photograph is dated 1909, a time when the K&M was under NYC control but operated as a separate railroad. The station sign shows the mileage to the line's eastern extreme at Gauley Bridge, West Virginia. Hidden by the utility pole at the right end of the sign is the name of the line's western terminus, Corning, only eight miles away. (OU.)

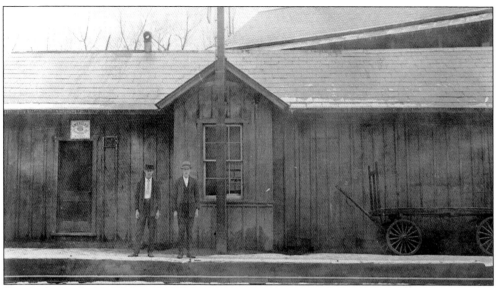

Hemlock, on the Z&W (later NYC) line between Corning and Shawnee, had two depots. The photograph above, dated 1905, shows the first, a rough frame building with board-and-batten siding and apparently no paint. The agent's bay window shows clearly, as does the sign advertising the American Express Company, which served this line for small shipments ranging from money to baby chicks to bathtubs. Not long after this view was made, Hemlock got its second Z&W depot, a replacement of the first and much more refined in its design and materials. It was also a frame building but boasted three different kinds of siding and much more attention to detail. Both photographs feature some of the locals posing for the camera, which seems to have been something of a cottage industry. (WED.)

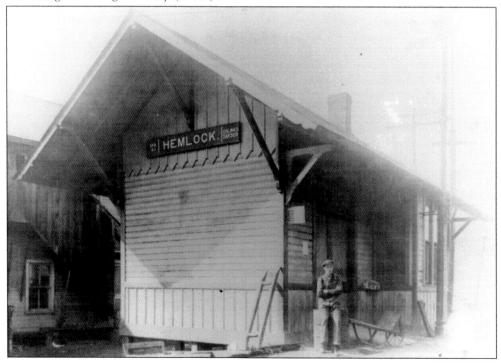

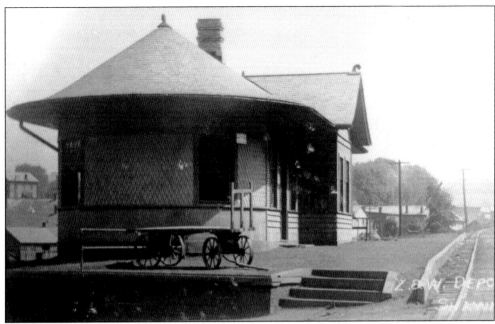

Not to be outdone by Hemlock, Shawnee claimed an even fancier Z&W depot. The midday sun shines down in the photograph above, which looks east during a quiet time between trains. The Z&W, which shared Shawnee traffic with the B&O line that came into the west side of town, had several coal mine spurs in the area. In the photograph below, departure time is near for the passenger run to Zanesville, perhaps No. 208, the 2:50 p.m. train that operated in the period around World War I. It would cover the 42.9 miles to Zanesville in 2 hours and 10 minutes. (LCBDA.)

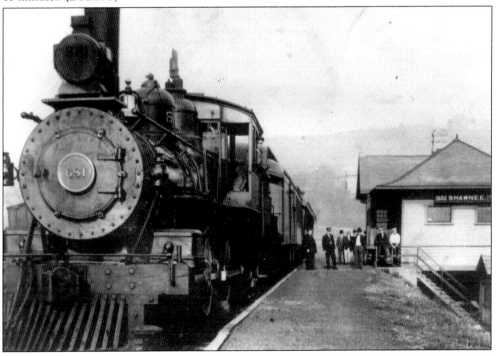

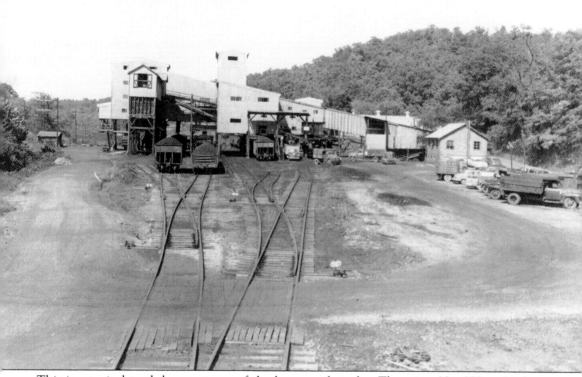

This is a typical track layout at one of the larger coal tipples. The mine, No. 255 on Little Bailey Run, operated between 1945 and 1963; this view probably dates from around the middle of that period. The single-track mine spur spreads out into several tracks that run beneath the tipple; each track runs under a chute that loaded cars with a single size of coal. These tracks were almost always laid out on a slight upgrade. Empty cars would be delivered by a "mine-run" train and pushed up the grade beyond the tipple; each car was then "tied down" by means of its manual brakes. When the tipple needed a car for loading, a worker released the brakes just enough to let a car roll and rode it slowly down the grade, braking it to a stop under the loading chute. Loaded cars would be rolled out from under the tipple in the same manner. Some mines had a winch and cable system to help position cars. This avoided having to keep a locomotive and crew on duty all day. (OU.)

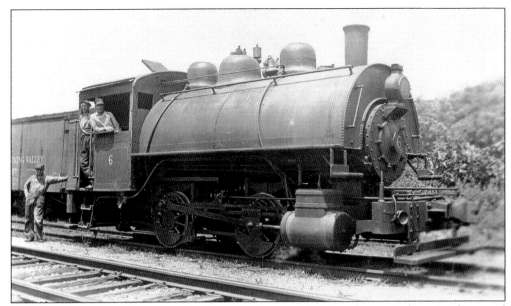

Yard locomotives stayed in a restricted area such as a railroad yard or an industry's sidings and spurs, moving cars around and making up and breaking down trains. Often called "goats," these machines seldom ventured onto the main line. As in these two photographs, they generally were small and had no leading or trailing wheels; all their weight was on their driving wheels to maximize pulling power. Their small-diameter wheels made them slow but strong. The view above shows such a locomotive at work in Haydenville, where it handled cars of products from the large clay products plant. The locomotive in the view below is a Hocking Valley Railroad switcher in the large yard at Nelsonville, where much of the region's traffic in black diamonds was made up into trains for shipment north. Crew members hold the kerosene lanterns that were a basic railroading tool. (Above, HPC; below, NPL.)

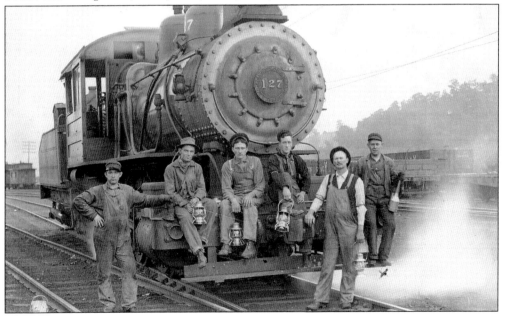

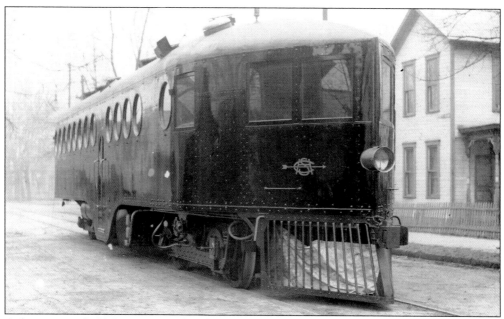

At least one early-20th-century railroad in the Little Cities did not use steam power. A line known locally as "the Traction" used the railcar shown in these views. An interurban, the line's formal name was the Hocking-Sunday Creek Traction Company, built from Nelsonville to Athens between 1910 and 1915. In the first year of operation, its only piece of equipment was a McKeen car, a wedge-nosed, gasoline-engined vehicle, one of only 152 built by the McKeen Motor Car Company of Omaha, Nebraska. Its massive cowcatcher, knife-edge nose, and porthole windows must have made it an odd sight indeed in the local streets. Difficult to operate and maintain, the car was gone within a year, and the line was electrified for regular interurban cars. Growing automobile traffic decimated the line's business, and it was abandoned in late 1932. (NPL.)

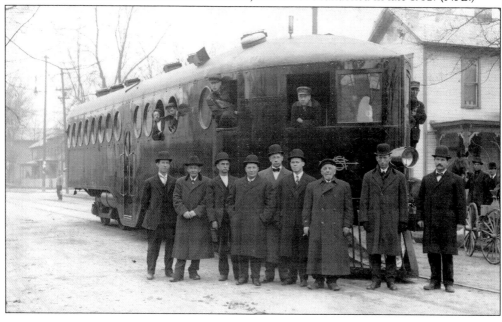

Not all freight traffic in the Little Cities region was coal, and a good portion of it was local. This 1881 payment receipt shows that the Hocking Valley Railroad carried 14 tons of bricks from Logan (probably from the brick plant there) to New Straitsville, 13 miles, for $9.31. The shipment was consigned only to "Catholic priest," but in a town where everyone knew everyone, the recipient would not have been hard to find. The bricks were for the new church, of course. (NSHG.)

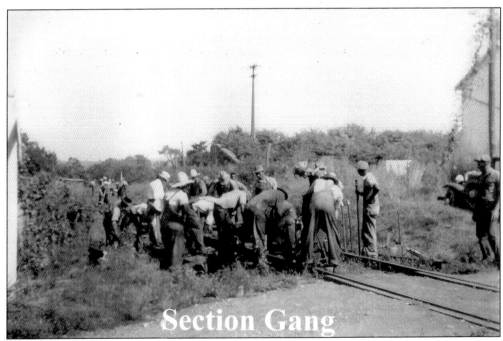

And where would the Hocking Valley spend that $9.31 in revenue from the car full of bricks? It and many other dollars went into track maintenance, not to mention the labor, fuel, taxes, bridge and building repairs, and countless other expenses needed to keep the line running. The railroad on which this section gang worked is not known, but every railroad had such gangs, especially in the days before mechanization of track work in the period around and after World War II. (LCBDA.)

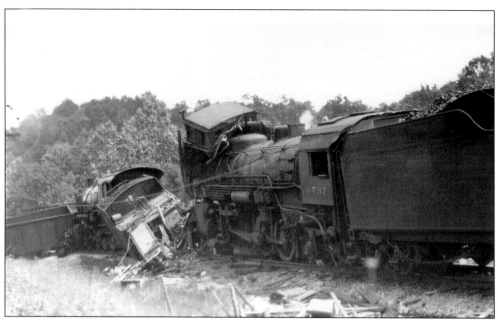

Railroad expenses come not only from wear and tear. A missed signal, a forgotten train order, bad weather, or a broken rail can lead to a disaster expensive in both money and lives. These undated photographs show a wreck somewhere on the T&OC, possibly around the World War II era. The head end of one train ran into the rear end of another. The offending engine has crushed a wood caboose between the engine's front end and the tender of another engine ahead of the caboose. That engine was running as a pusher to help get a coal train moving on an upgrade. Ironically, wood cabooses were placed behind such engines because their frames were too weak to sustain the force of the pushing engine. One can only hope the coal train's crew jumped clear in time. (WED.)

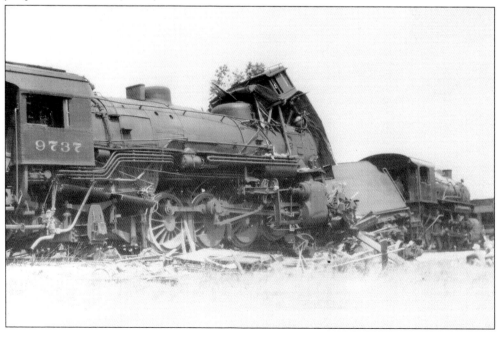

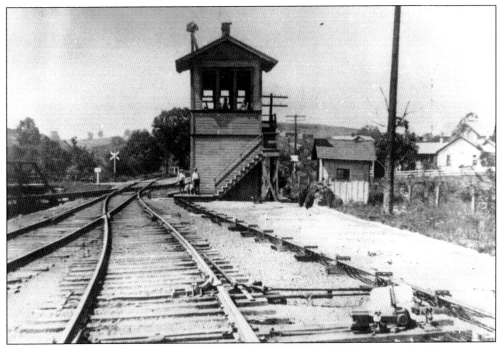

This view, taken in the north end of Corning, shows the tower that controlled the crossing of the T&OC and the Z&W. The metal piping at the right is switch rodding, moved by large manual levers in the tower to throw switches and change signal indications. A device called a derail, lower center, keeps stray rolling stock from moving from a siding onto the main line by mistake. (LCBDA.)

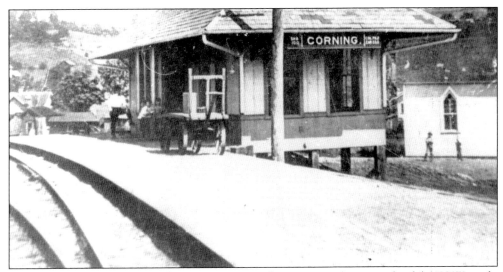

South of the T&OC crossing, the Z&W passenger depot was on the west side of the Z&W track, which passed near downtown Corning and then curved behind the background hills on its way to Congo, Drakes, and Shawnee. A baggage cart waits in the sun for the next express shipment or mail delivery. (PM.)

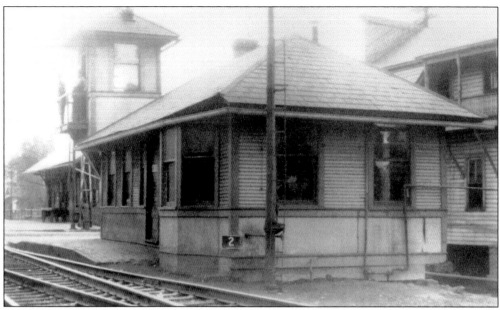

Corning was the principal railroad town of the Sunday Creek watershed and had substantial rail-related facilities. Next to the downtown commercial district were the passenger depot, the yard office, and the freight house of the T&OC. The photograph above looks south from just north of the Main Street crossing and shows the yard office and its corner tower; the tower controlled the crossing gates that protected the multitrack yard. South of Main Street and partially hidden is the passenger depot. Space being at a premium, the depot was built directly over Sunday Creek, which passed immediately behind the yard office. At the right is one of the downtown commercial buildings, with a second-story side porch. The photograph below shows the freight house, which stood across the tracks from the depot. (LCBDA.)

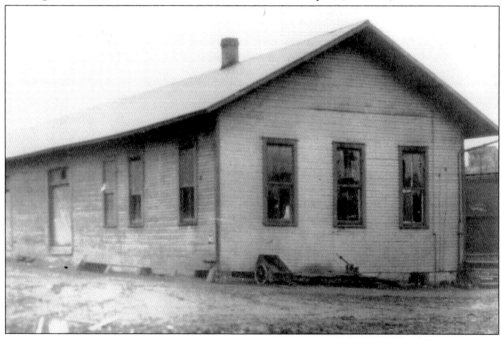

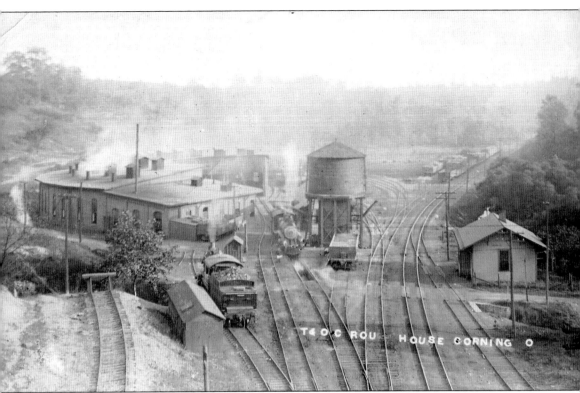

South of Corning were the main T&OC yard and engine terminal. This photograph looks south and shows the roundhouse, the water tower, and the yard and operator's office. The T&OC and the K&M once met at this yard, exchanging traffic and forming a through route between Columbus and coal-mining regions east of Charleston, West Virginia. Once the T&OC gained control of the entire line, Corning became a division point at which train crews were changed and locomotives were serviced. This photograph probably dates from between 1910 and 1920. (WED.)

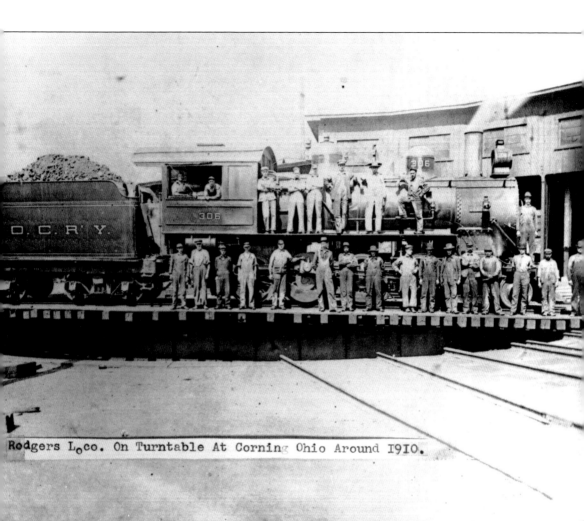

One of the T&OC's road locomotives takes a spin on the Corning turntable around 1910. The tracks radiating from the turntable lead to stalls in the roundhouse, forming a compact facility for storing, servicing, and turning locomotives. The turntable appears to be manual, requiring workers to rotate it by pushing on stout handles. It was also called an armstrong turntable, since it required strong arms. A good engineer could stop his locomotive precisely at the point where the weight was evenly distributed over the turntable's center pivot, making it easier to turn. (OU.)

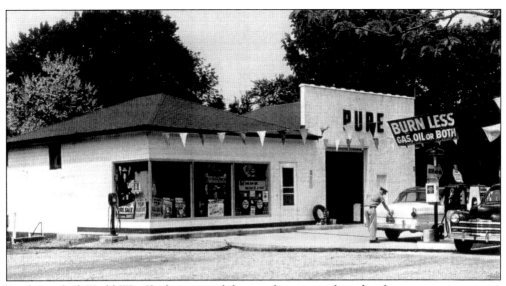

By the end of World War II, the automobile was the principal mode of transportation across the country, creating an entire new industry and an expanded employment base at businesses such as local service stations. This also marked the near-total demise of the passenger train. By the 1950s, train service was gone from the Little Cities region. Also in the 1950s, many people, railroaders and others, lamented the passing of the steam engine. At the end of World War II, steam power still was predominant on the nation's railroads, but within a dozen years, it had been almost entirely replaced by diesels. The end of steam at the NYC roundhouse in Corning came on November 10, 1952, when No. 1450, the last steam engine serviced there, departed for good. The photograph below shows one of the road diesels that replaced steam on all the lines of the NYC by the mid-1950s. This changing of the guard on the railroads of the region seems, in retrospect, to be symbolic of the change occurring in the lives and fortunes of all the Little Cities at that same time. (Above, HPC; below, LCBDA.)

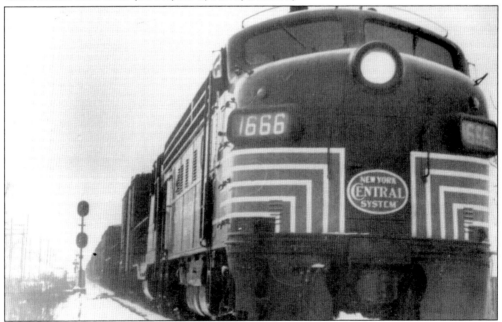

Three

COALFIELD COMMUNITIES

The communities of the Little Cities of Black Diamonds have a strong sense of place. This arose from their geographic location and the local topography; from their patterns of streets and roads, which were strongly shaped by the topography; from their scale and development patterns; and from the distinctive architectural character of the region's buildings, many of which have survived fire, flood, and neglect to last far longer than any of their builders likely ever imagined.

The Little Cities were boomtowns, a product of and shaped by the Hocking Valley coal boom between 1870 and the 1920s. Despite abundant clay supplies in the area for brick making, most buildings were of frame construction. This was an inexpensive means of building quickly to meet the needs both of coal operators interested in basic housing and other facilities in company-owned towns and of developers and speculators anxious to plat towns and rent or sell homes and business buildings. In their design and construction, these buildings reflected their era, displaying the designs and ornamentation typical of the late-Victorian period. Still they were built with a distinct local flavor, employing forms, scale, and features unique to the region.

The Little Cities were, of course, more than just their buildings. The people who lived and worked there gave these communities life. Miners drawn by employment opportunities, businesspeople drawn by the profits to be made meeting the miners' daily needs (including goods, services, and beverages), mechanics, laborers, railroad workers, and others came to the region during the boom. After the boom ended, many moved away, but others stayed and continued to live and invest in what had become their and their descendants' hometowns. Both during the boom and after, change was a constant in the lives of these people and not always for the good. Yet they and their communities have persisted and continue today to tell the compelling story of their past.

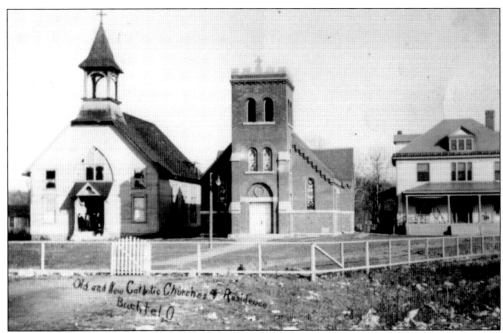

The community of Buchtel, originally known as Bessemer, was established in the late 1870s when the Akron Iron Company built an iron furnace on the flat bottomland where Monday Creek and Snow Fork join, northeast of Nelsonville. Company head John R. Buchtel, wealthy and well known in Akron, gave the town its name. Original grand plans for a town that would rival Pittsburgh, Pennsylvania, never fully developed, but the iron furnace, as well as coal and iron mines, made Buchtel a lively place. These photographs are undated but probably are from around 1905 and give a sense of the town's character. The view above is captioned, "Old and New Catholic Churches and Residence," while the one below shows the J. R. Buchtel Company store and opera house, a substantial and imposing brick building in a late-Victorian style. (Above, NPL; below, JS.)

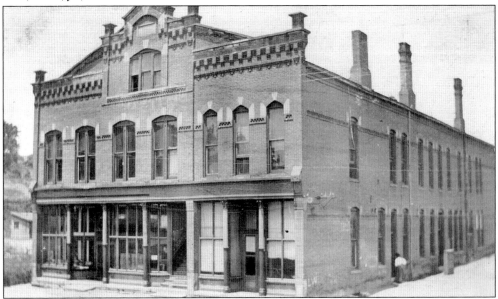

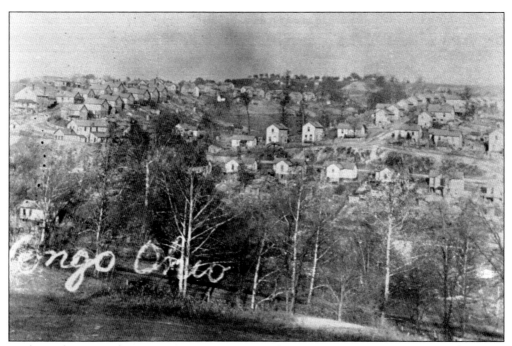

In the early 1890s, the Congo Mining Company developed a town called Congo, about two miles northwest of Corning. Perched on a hillside above the recently completed Columbus, Shawnee and Hocking Railroad line, it was fenced, with limited access. Much of life there was under company control, but it was known for its general labor peace and its productive mine. The hillside had two high spots, Hungarian Hill and Colored Hill. The Hungarian language lasted here into the 20th century, while Congo's African American residents moved early on to Rendville and other communities. The photograph above looks east from a hill west of Congo with the railroad in the foreground. The photograph below shows Stenson's Store around 1912, down the hill from the town. Congo's new school is above the building on the right. (WED.)

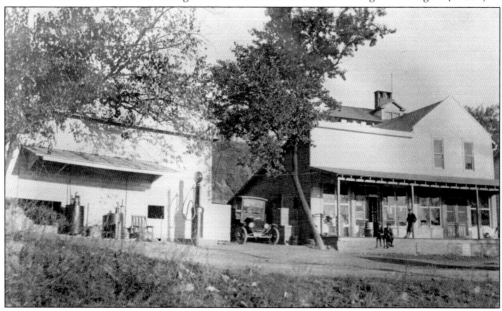

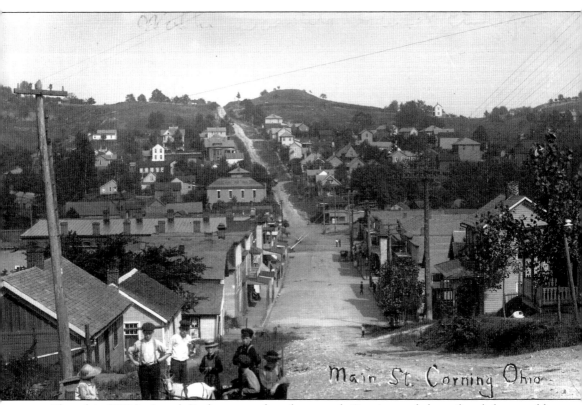

Platted in 1879 by Joseph Rodgers on a farm he owned, Corning and the railroad that would be so much a part of its future grew together. Building lots in the new town sold quickly, and late in 1879, the first train from Columbus arrived. The railroad and much of the commercial district of Corning sat on the narrow bottomlands of Sunday Creek, while most of the residential development occurred on the hillsides east and west of the creek. This view, on a postcard dated 1908, looks east down the hill along Main Street from the west side of town. The usual complement of well-hatted boys observes the photographic process. Corning was at first called Ferrara, but when the rail line coming from Columbus went bankrupt building the Moxahala tunnel around 1873, New York businessman Erastus Corning revived the line, and Ferrara became Corning in his honor. (WED.)

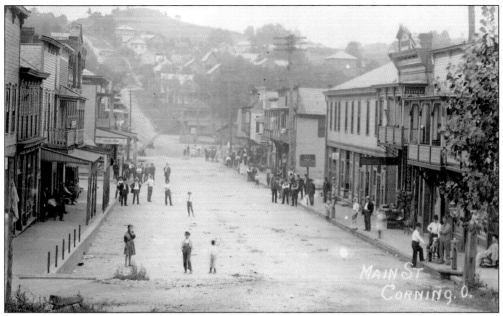

The view above, postmarked 1909, also looks east along Main Street in Corning, but from down at the bottom of the hill; compare this view to the one on page 44. The photographer has attracted a considerable crowd this time, all of them emerging from the well-kept commercial buildings or stopping along the sidewalks that kept people out of the mud of the unpaved street. The Mercer Hotel is at the middle right, and in the distance are the crossing gates where the T&OC line passes through. The photograph below is a view of Valley Street in Corning, which, like Main Street, has several buildings with second-story porches. Some are supported by posts, but others are the bracketed overhanging porches unique to the Little Cities region. (WED.)

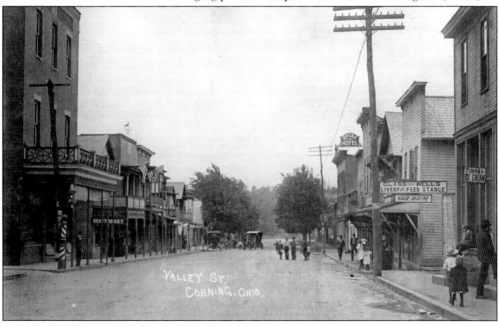

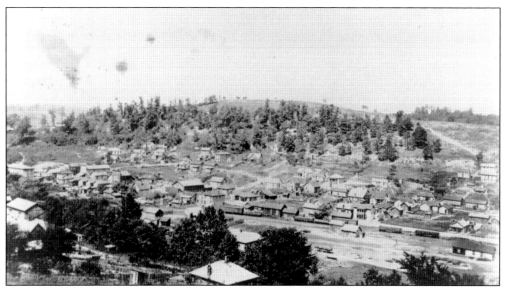

At a point where Sunday Creek turned westward and then southward, the Allen family and others platted the town of Sedalia in May 1882. The K&M had already built its line through this area, and after a period of slow growth, the new town began to take off, becoming one of the largest of the Little Cities. In 1886, it was renamed Glouster. The photograph above is a 1911 view of the nearly 30-year-old community, looking east from hilltop to hilltop. The photograph below, made in 1907, shows the destructive flooding that was occasionally visited upon Glouster and other communities that filled the often narrow floodplains of Sunday and Monday Creeks. The view looks southeast, just south of where today's State Route 13 turns east as it leaves the north end of town. (Above, LCBDA; below, OU.)

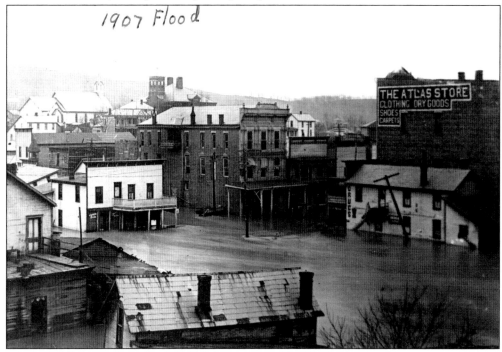

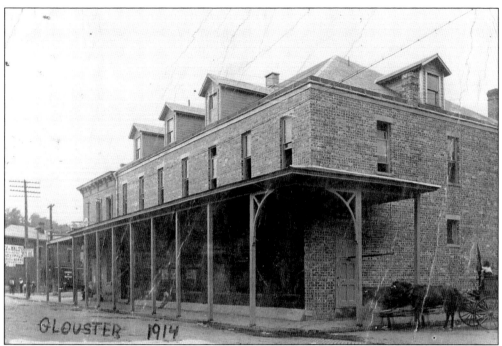

As a major commercial center along the eastern edge of the Little Cities region, Glouster saw the construction of some substantial buildings. The photograph above is a 1914 view of Stoeklein's Meat Market, which appears to have been built of large, heavy paving bricks rather than the standard-size house bricks. The horse-drawn wagon at the right was on borrowed time as the Ford products in the photograph below began to dominate transportation in the Hocking Valley Coalfield. Perhaps just delivered from one of the Ford Motor Company's Detroit-area factories, these cars may have arrived on the T&OC in special automobile boxcars. They have drawn a small but admiring crowd in front of the local dealer's showrooms. Hard-paved streets and roads began to make automobile transportation practical around the World War I period. (OU.)

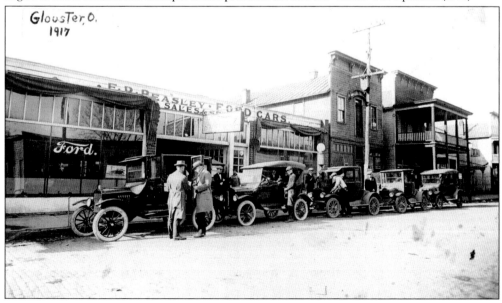

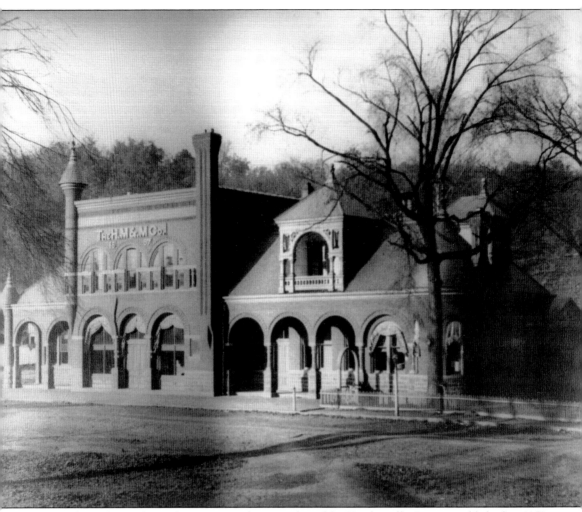

Nowhere else in the Little Cities was there anything like Haydenville. It was established in 1852 when industrialist Peter Hayden of Columbus began mining coal in Hocking County. The 1869 arrival of the Hocking Valley Railroad helped to secure the community's place as an industrial center, and Hayden's coal operations soon expanded into clay products too, especially fireclay. Under the Haydenville Mining and Manufacturing Company, established in 1882, Haydenville became a classic company town famous for the sewer pipe, drainage tile, firebrick, paving bricks, chimney pots, and—not least—the rows of company housing and the church, school, and company store, all built of products of Hayden's plant. The 1887 store and office building in this photograph have been demolished, as has the school, but many brick and clay tile houses survive today, as do the church and one last circular home built of silo tile. (HPC.)

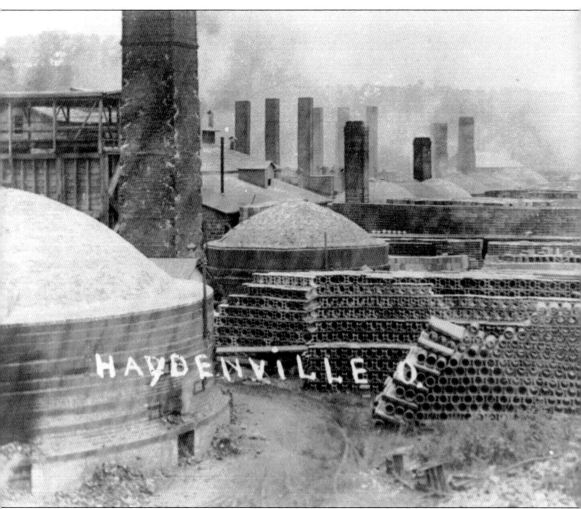

This undated photograph shows some of the clay storage bins, circular kilns, smokestacks, and piles of products such as sewer pipe and structural tile that were the lifeblood of Haydenville. The clay products plant was large, running about a mile along the west side of the village. All of it—the plant, the village, and also the railroad and the Hocking Canal—were on the narrow floodplain of the Hocking River, squeezed in on the east and west by high hills. (HPC.)

The village of Haydenville itself was primarily residential in character. Since it was a company-owned town, it did not have a traditional downtown commercial district with independent businesses, so its streets were lined mainly with homes. The company used several different designs in the houses it built for its employees. Some were single-family houses, others doubles. Some had flat roofs, and others had gable roofs, often with decorative wood trim. The photograph above shows some of the larger single-family, two-story homes, all of which had porches and slate roofs. The photograph below shows one of the less-common frame houses. It is the home of the local physician, Dr. R. M. Anderson, with his combination hearse and ambulance parked outside. (HPC.)

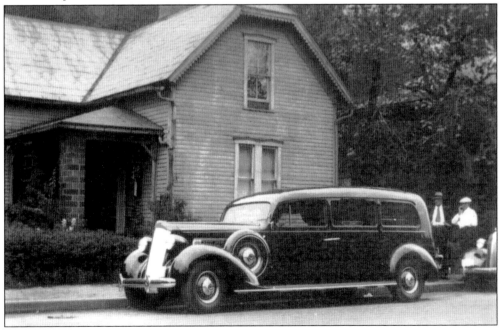

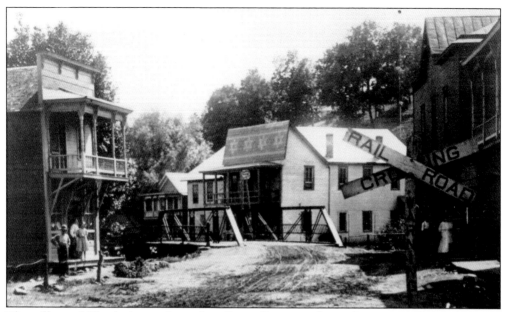

The village of Hemlock was located in Perry County a few miles east of Shawnee. It was squeezed into the narrow valley of the West Branch of Sunday Creek, hard by the Z&W branch to Shawnee. The photograph above, a postcard view postmarked November 2, 1910, looks south on Main Street. The Z&W depot is just out of the picture to the left, and the turn in the road at the creek crossing is in the center background. Note the patterned slate on the oddly shaped roof of the building behind the bridge. In the photograph below, the view is northward from the south end of Main Street. Grass grows liberally on the unpaved street. Almost everything in these views is gone today. (WED.)

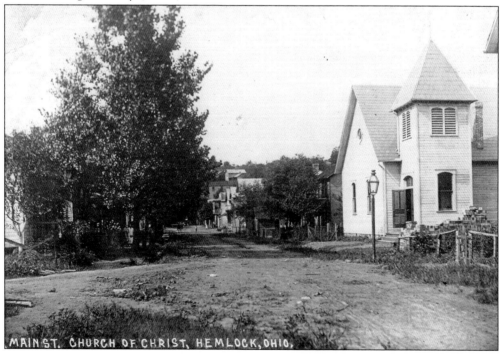

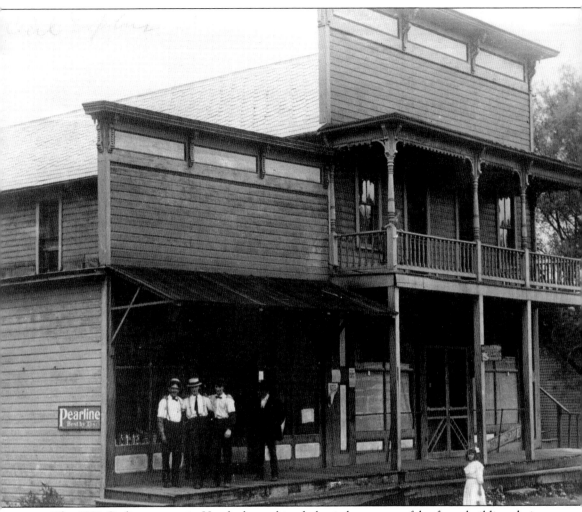

The 1881 Garlinger store in Hemlock combined classic boomtown, false-front building design with an ornamented second-story residential porch, a type common throughout the Little Cities region. This porch, supported by stout posts, was different from the cantilevered, bracket-supported overhanging porch unique to the area. Pearline (advertised on the sign to the left of the three men in shirtsleeves) was a coarse white laundry soap made in New York City. (WED.)

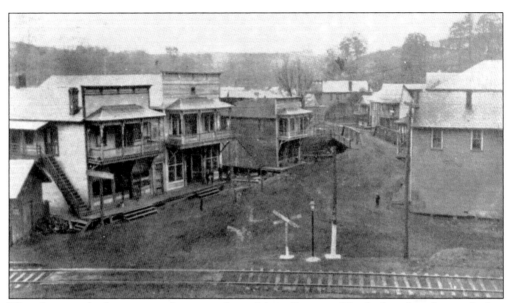

The photograph above is another view down Main Street in Hemlock, taken from a higher angle and giving a better view of some of the buildings. The railroad depot is at the left. In the photograph below, the West Branch of Sunday Creek has gone on a rampage, wrecking buildings and leaving a general mess. This was in 1927, the view looking west along the Z&W branch line to Shawnee. (LCBDA.)

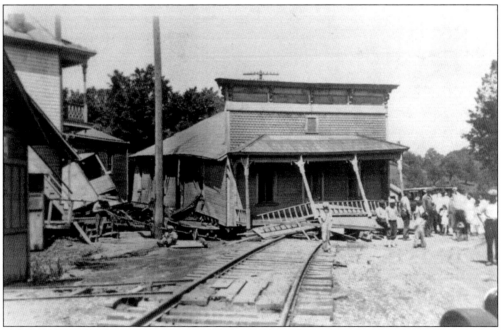

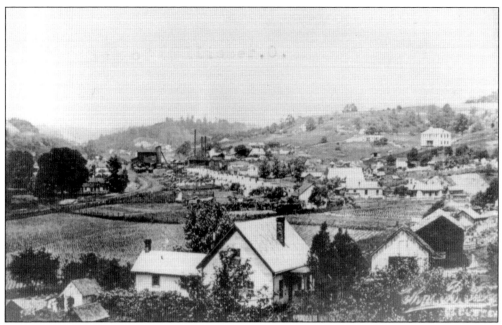

Hollister lies about two miles west of Glouster in the valley of Mud Fork, a tributary of Sunday Creek. This view looks west over the town. A row of company houses is at center right, with a large coal tipple to the left. Coal mine openings penetrated the hills both north and south of town. The roadbed of the curving railroad line today is occupied by State Route 78. (SM.)

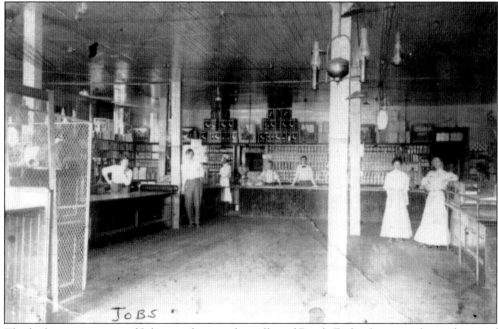

The little mining town of Jobs was deep in the valley of Brush Fork, about a mile southwest of Murray City in Hocking County. Mines on Brush Fork were served by a branch of the Hocking Valley Railroad. Isolated as it was, Jobs had a well-stocked store with plenty of staff. For a period of time, the Jobs mine held the world record for tons of coal produced in one day. (JS.)

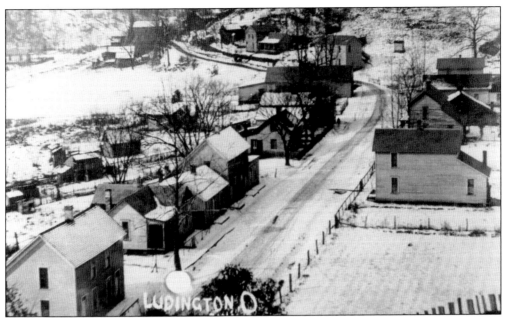

From a steep hillside outside Hemlock, this view looks over the village of Ludington. The photograph gives a good idea of the topography typical of the region. Ludington is at an elevation of about 770 feet, while the surrounding hilltops are at nearly 1,000 feet. Today State Route 155 passes to the left of the row of buildings in this view, and most of this land is covered by forest. (WED.)

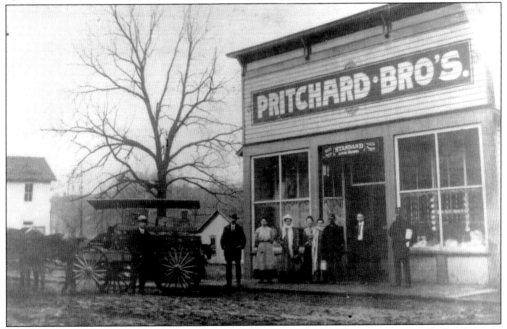

The false-fronted Pritchard Brothers store, in the east end of Ludington, is open for business in this late-19th-century view. Leafless trees, warm clothing, and a hopelessly muddy road suggest a winter or early spring date. Wood boardwalks, like the one on which the assembled party is standing, made pedestrian life easier in many communities of the region. (WED.)

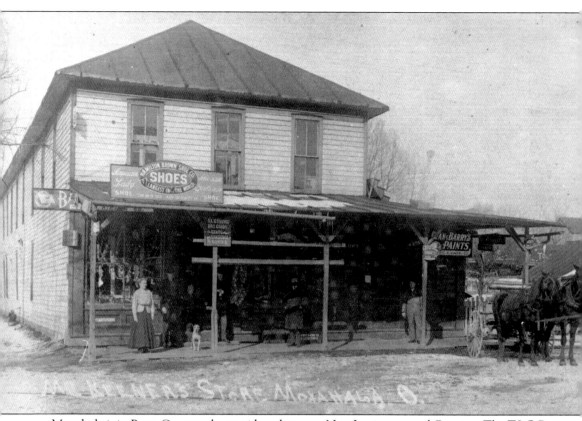

Moxahala is in Perry County, about midway between New Lexington and Corning. The T&OC arrived, after a long and difficult construction period, in 1874, which spurred development in the two-year-old community. The enterprise in this photograph, identified only as "Mr. Keiner's Store," is typical of the modest businesses that served the Little Cities. (LCBDA.)

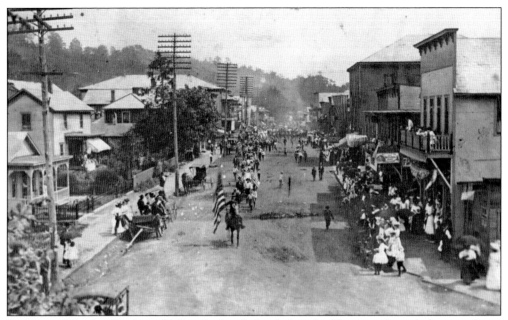

Early in 1873, the Hocking Valley Railroad decided to build a new branch line up Snow Fork, northeast of Nelsonville, to tap the rich coal seams concealed in the hills. Speculators immediately began platting new towns, one of which was Murray City, named for one of its developers, J. Murray Brown of Somerset. It soon grew into the thriving community shown in this 1909 photograph. (OU.)

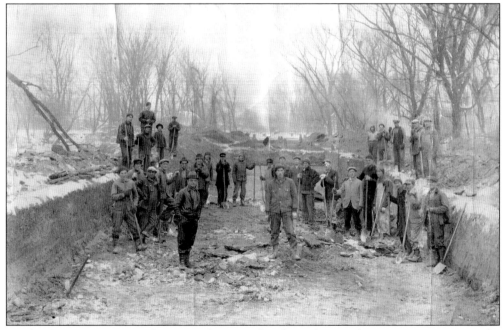

Much of Murray City was linear in character, lined up along today's State Route 78 in the narrow valley of Snow Fork. Just south of the center of town, probably in the early 1900s, a crew—working only with shovels, judging from this photograph—was channelizing Snow Fork to make room for highway improvements and reduce the danger of flooding. (JS.)

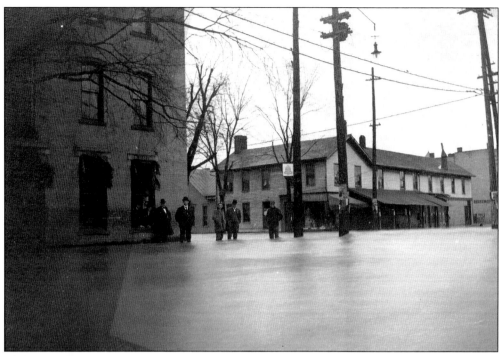

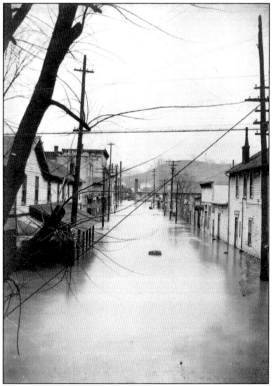

Late winter and early spring can be treacherous in Ohio, when a sudden warm-up can bring heavy rain that falls on frozen ground. Unable to soak into the soil, water quickly overwhelms creeks and rivers, often with disastrous results for cities and villages. This happened in Nelsonville in mid-March 1907. In the photograph above, which looks northeast from the corner of Columbus and Hocking Streets, the rear part of the Dew House Hotel (still standing on the square today) is at the left. In the photograph at left, the view is to the south and was taken from a window of the Dew House. The Hocking River soaked almost the entire city. (NPL.)

Another view from the Dew House, in the photograph at right, looks across the flooded downtown square and northward along Columbus Street in Nelsonville. Most of the buildings in this photograph still stand today and are part of the Nelsonville Historic District. In the photograph below, the Hocking Valley Railroad's location close to the Hocking River proved its undoing. The railroad rebuilt the track and continued serving the region for many decades. Today this section is part of the Hocking Valley Scenic Railway. (NPL.)

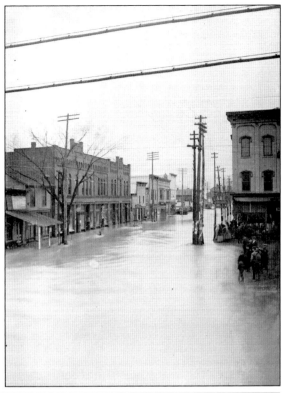

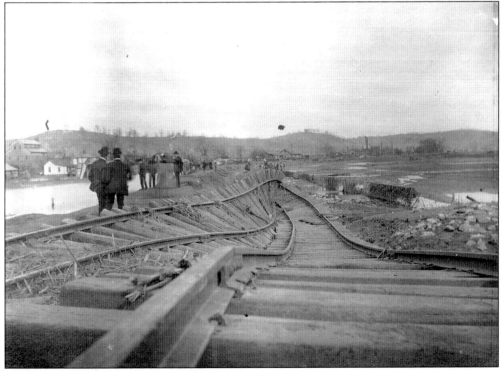

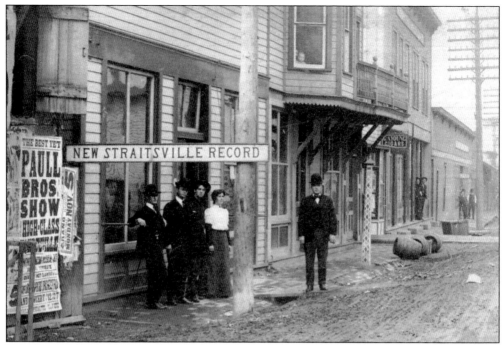

New Straitsville (as distinguished from the nearby hilltop village of Straitsville) was platted in the spring of 1870 in the valley of a creek that fed Monday Creek. It was the first of the region's boomtowns, spurred by arrival of the Hocking Valley Railroad from Logan to tap the rich New Straitsville coal vein. As the photograph above shows, by the late 19th century New Straitsville was a substantial place. The poster at left advertises a "high-class vaudeville" show coming to town. The railroad and business district took up most of the flat bottomland, so most of the town was built on the hillsides. The photograph below dates from around the early 1920s. Note the highway sign advising that Shawnee was only two miles away, but it was over a very hilly and curving road. (NSHG.)

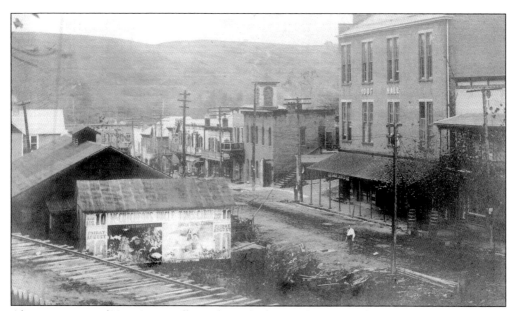

Above is a view of New Straitsville made in the late 19th century along today's State Route 93 to Shawnee. The view shows the west side of the road, with the town hall in the center. Most other buildings in this scene are gone, but the town hall still stands as a local landmark. At the left is an unfinished spur track of the Hocking Valley Railroad that would eventually serve a coal mine above the town. Below is a view of New Straitsville looking north. At the upper left center is the New Straitsville Public School, built in 1916, with today's State Route 93 in front of it; the school is now used as a senior housing facility. In the foreground, below the brow of the hill, some freight cars sit in the Hocking Valley Railroad yard. (NSHG.)

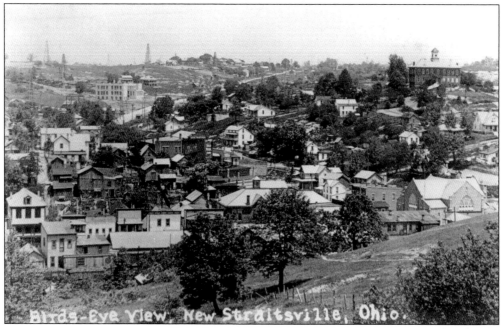

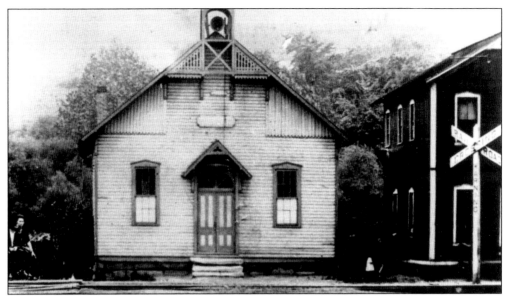

In 1879, Chicago businessman William P. Rend established a mine and town about a mile north of Corning, east of Sunday Creek. Naming the place Rendville, Rend gradually increased coal production as rail transport became available, and the town prospered. This view looks toward the town's church on its original site. Between 1880 and 1900, Rendville became the primary place where African Americans of the Little Cities region lived. (LCBDA.)

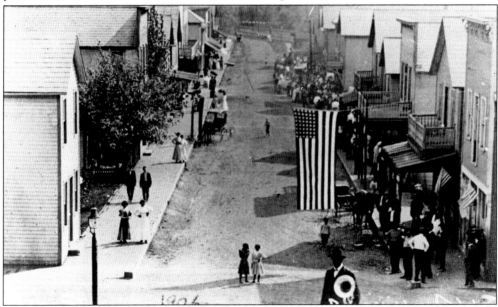

In 1906, a photographer climbed partway up the steep hill in the north end of downtown Rendville to record this scene. It is looking south, with the T&OC main line in the background and the city of Corning off to the left, out of view. The church in the photograph above was moved to the end of the row of buildings on the right, where it still stands today. All the other buildings in this photograph have been demolished, except the town hall in the left foreground, which still functions as the seat of government in Rendville, Ohio's smallest incorporated village. (OU.)

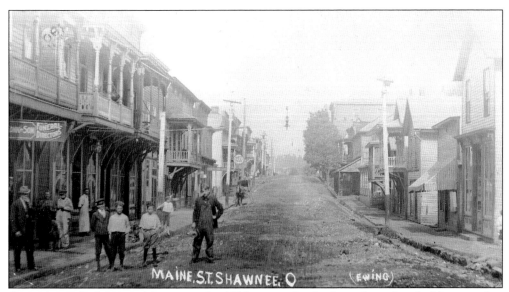

Since the end of the coal boom in the 1920s, many Little Cities have lost buildings to fires and demolition, while other communities have disappeared entirely. The village of Shawnee, established in 1873, has survived more intact than most. This late-19th-century view of Main Street, which looks west toward the three-story Knights of Labor/Knights of Pythias building, is not too different from what a visitor can see today. Shawnee can boast more surviving examples of the region's distinctive overhanging porches than any other place and ranks nationally as one of the best-preserved coal-mining boomtowns. (LCBDA.)

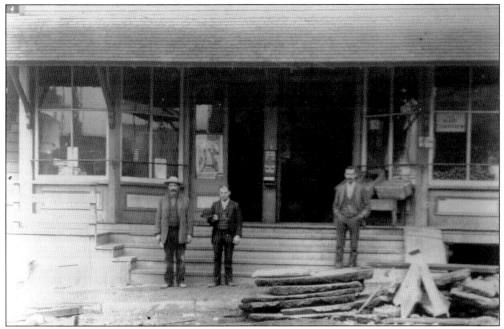

This Shawnee commercial building, boasting a generous front porch with steps and a canopy roof to protect pedestrians from the weather, was fairly large by Little Cities standards. The large four-paned display windows were typical late-19th-century practice, from the days before large pieces of plate glass were available. (LCBDA.)

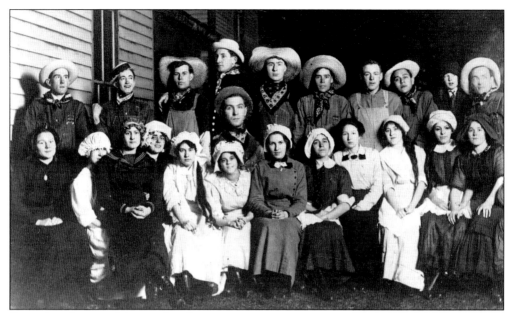

Since this photograph has neither date nor caption, imagination will have to tell the story. In the days before radio and television, social and fraternal organizations and events such as concerts and plays were important means of entertainment in smaller communities like those of the Little Cities. A good guess would be that this photograph shows the cast of a local stage production of some sort, apparently one that celebrated straw hats and granny-style pajamas. (OU.)

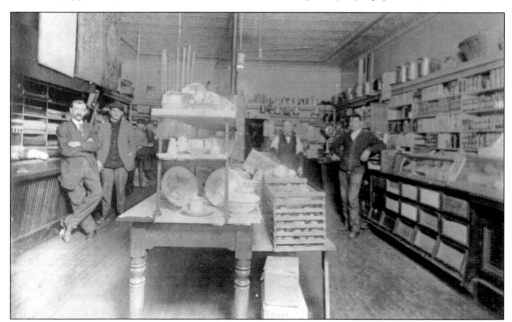

C. T. Griffith had a well-stocked general store along Main Street in Shawnee. Note how much these general stores resembled today's "big box" stores, at least in their wide selection of goods. From oriental rugs hanging from the ceiling, to china and crockery, to crates of spuds and shelves of canned goods, a shopper could find pretty much everything he or she needed. And there were plenty of helpful clerks, no self-service required. (LCBDA.)

Four

LIFE AND WORK IN THE LITTLE CITIES

No one would argue that making a living in the Little Cities of Black Diamonds was easy. Miners, railroaders, and clay workers faced daily danger. Retail stores and service businesses had to worry about costs, employees, and loan payments. The ups and downs of the coal market touched everyone but were beyond anyone's control.

Two intertwined themes influenced Little Cities life—labor history and African American history. African Americans came to the region when they were hired (unwittingly) as strikebreakers. They were met with prejudice and violence, but as the labor movement gained momentum, they gained acceptance. Segregation was still the norm, with blacks generally living in separate communities, but by the early 20th century, most of the conflict with white residents was gone.

All miners had common concerns—wages, steady work, and good working conditions. A long unionization effort rallied miners in a common cause of national importance. As early as the 1850s, without formal organization, miners near Nelsonville struck over wages, and by the mid-1870s, the unionization movement began attracting national labor leaders. Welshman Christopher Evans, later executive secretary of the American Federation of Labor under Samuel Gompers, played a critical role in organizing through the National Progressive Union. Competing with Evans was the Knights of Labor National Assembly No. 135 in Shawnee, led by William Bailey and William T. Lewis. The two joined forces to form the United Mine Workers of America in Columbus in 1890. At this meeting was Richard L. Davis, the principal figure in the effort to admit African American miners to the new union.

Historic labor movement sites still exist. Robinson's Cave in New Straitsville is open to the public. The cave is where both the 1884–1885 strike and the 1890 meeting in Columbus were planned. The Knights of Labor opera house, assembly No. 135's headquarters, stands in Shawnee. Careful observers will note that the "K of L" carved into a stone on the building was later altered to read "K of P" for the Knights of Pythias, later occupants of the building. Another "memorial" is the mine fire near New Straitsville, set in 1884 during the great Hocking Valley coal strike and still burning.

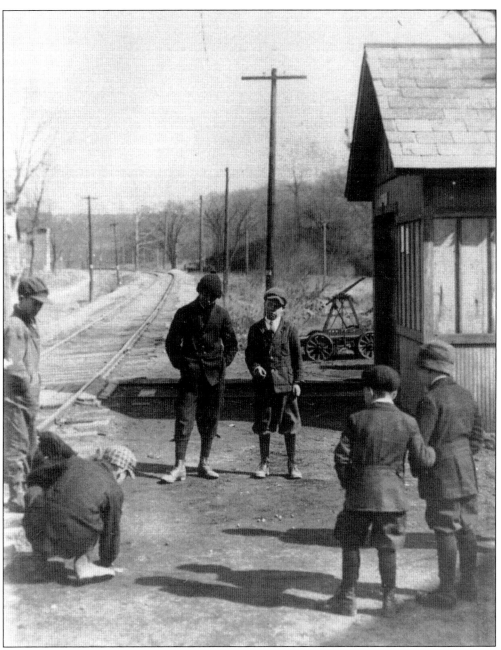

A sunny day in early spring, probably on a weekend when school was out, was a great time for a game of marbles. Labeled "Hemlock Boys," this photograph documents one of the joys of childhood: free time without adult supervision. Most of them still in short pants, these boys found a flat, clear spot down by the Z&W track (probably in the hope that a train would appear) and are quite focused on their game. There is some disagreement among captions for this picture, but the boys have tentatively been identified as, from left to right, Rudolph Kunce, Ralph Fitzer (or maybe Willie Redfern), Elec Oris, possibly Dicky Marfell, and the Springer brothers. The view looks east along the railroad, with a manually powered handcar, parked by the section crew's shed, in the background. (WED.)

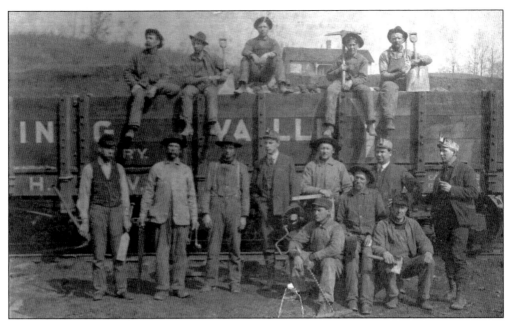

Adults had precious little free time; there was much coal to dig out and load into railroad cars. This group of New Straitsville miners poses around a loaded Hocking Valley Railroad car. Picks and shovels were the primary tools in the era before mechanization of the mines. Included also are augers, used to drill the coal face to set a dynamite charge. This photograph is from around 1900. (NSHG.)

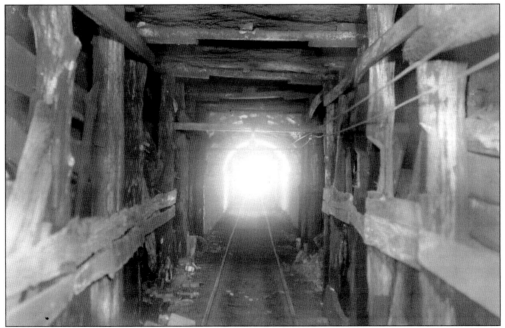

A coal miner faced scenes like this every day. Stout timbers, or props, hold up the roof over an entry wide enough for the narrow-gauge mine cars. Some seams were so thin that a miner might spend his entire shift lying on his side, not the best position from which to wield a pick, shovel, or auger. (HPC.)

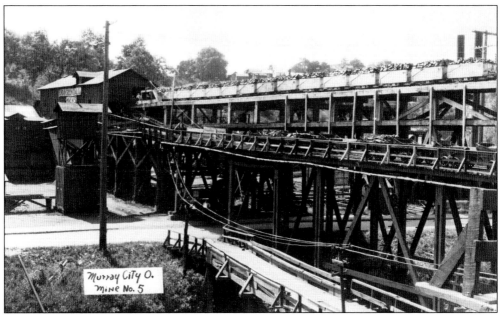

There was work to do outside the mine too. This is the tipple of the Sunday Creek Coal Company mine No. 5 at Murray City, seen earlier on page 17. The long trestle carries loaded mine cars into the tipple and empty ones out on their way back into the mine. There is no sign of electric lines for mine locomotives, so it appears that animals still provide the motive power for the dozens of cars. This mine operated until 1952. (OU.)

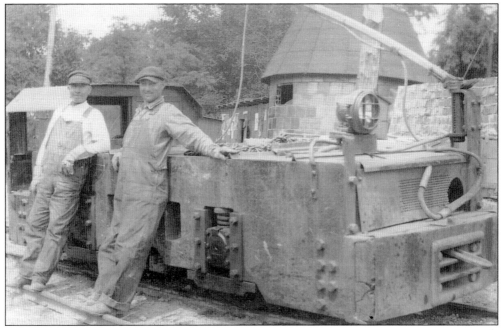

At least as large and lumbering as a horse or mule, electric mine locomotives did away with some of a mine's backbreaking labor. This one hauled cars of clay from underground deposits at Haydenville, but the same type of machine was used in coal mining. Stepping on the rails was and still is forbidden for safety reasons because they are slippery with oil. (HPC.)

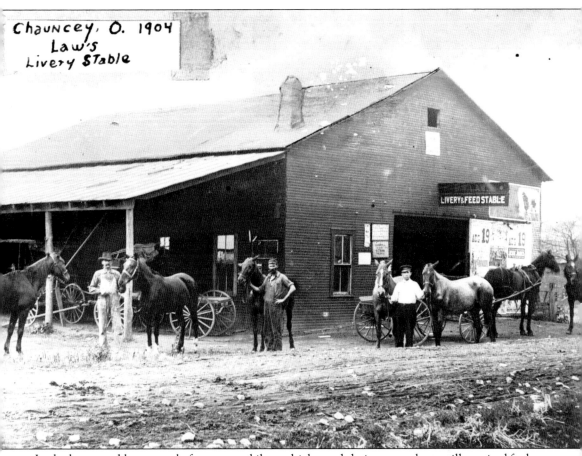

In the horse-and-buggy era before automobiles, vehicles and their power plants still required fuel and servicing. Law's Livery Stable in Chauncey (pronounced "Chancy"), north of Athens, was typical of many such enterprises, and on this day in 1904, it appears to have plenty of business. It is remarkable how quickly this all faded away over the next 20 years as the horseless carriage took hold of the public imagination and people like Henry Ford put it within reach of almost everyone. (OU.)

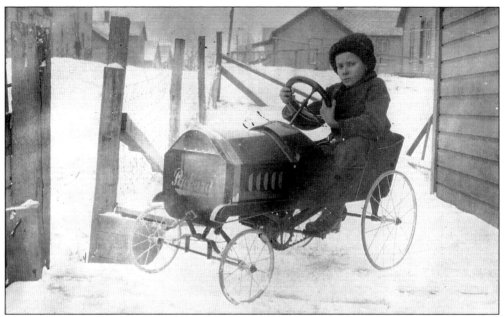

About 8 or 10 years later than the livery stable scene on the previous page, over in Congo James Preest poses proudly (and seriously) with his Packard pedal car. Its spindly wheels probably did not provide much traction in the snow, but in fine weather what a ride it would give the young man! In the background are several of the community's modest frame company-owned houses. (LCBDA.)

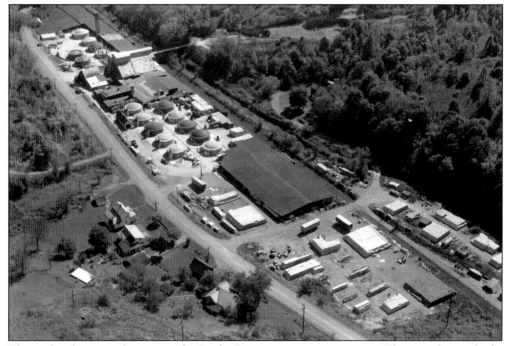

The scale of some industries in the Little Cities was quite impressive. This aerial view looks southeast at the large brick plant at the west end of New Straitsville, probably sometime in the 1950s. The distinctive circular kilns stand out from the other structures. (NSHG.)

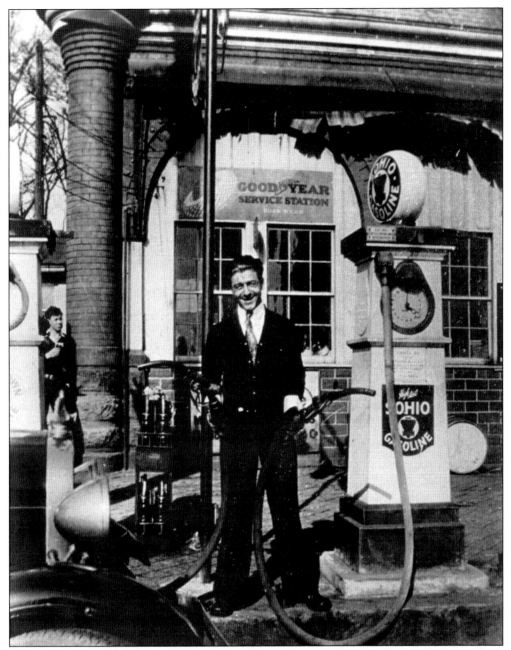

Once one drove his or her car into Haydenville on the town's newly paved road, Shorty Seels was happy to check the oil and fill the tank. The automobile may have put livery stables out of business, but it opened many other opportunities for entrepreneurial people. It also gave the boys of the town something to watch besides trains; note the lurking lad in the background. (HPC.)

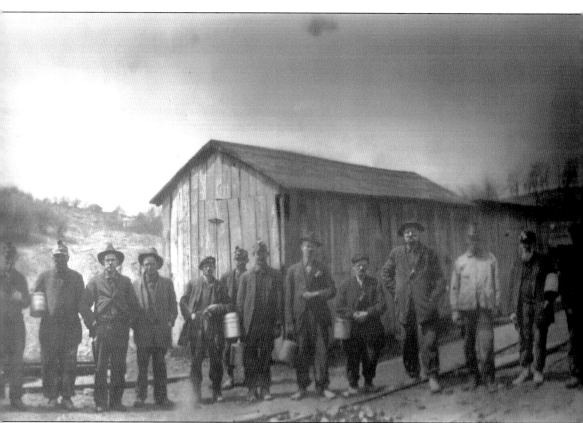

Judging from their dirty faces and clothes, these miners appear to be heading home from their turn underground. Having put away their mining tools, they are armed only with their metal lunch buckets. The location of this photograph is not noted, but the background view shows the stark and desolate landscape that was a common by-product of coal mining. (NSHG.)

1901-1927

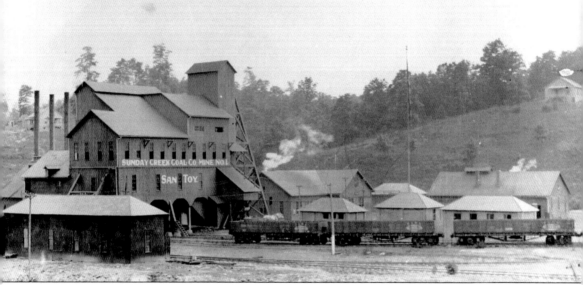

There are three methods of underground coal mining. A drift mine would be located where the edge of a coal seam cropped out, usually along the side of a creek valley. Miners simply dug back into the hillside along the coal seam. Slope or shaft mines tunneled into the ground to reach coal seams that did not crop out. A slope mine used a downward-angled tunnel that allowed use of narrow-gauge mine cars for hauling; a shaft mine had a vertical tunnel that required use of an elevator. This view of the Sunday Creek Coal Company's mine No. 1 at San Toy, in Monroe Township, Perry County, was among the larger mining operations. It ran from 1901 to 1927, and the angled framework of the elevator mechanism indicates it was a shaft mine. The shaft went down 195 feet to reach the coal seam. (OU.)

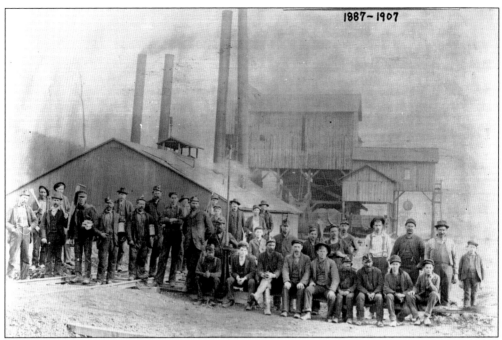

Coal mines were utilitarian, no-nonsense business enterprises, more often than not identified only by a coal company name and a number. Some mines, though, broke that mold. In the photograph above, miners and tipple workers (including some very young boys) pose outside the Jumbo Mine (also called No. 311) at Oakdale, on the rail line shared by the Z&W and the T&OC. In the photograph below is the distinctively named Struggling Monkey Mine near Nelsonville. The source of the name so far is unknown. (OU.)

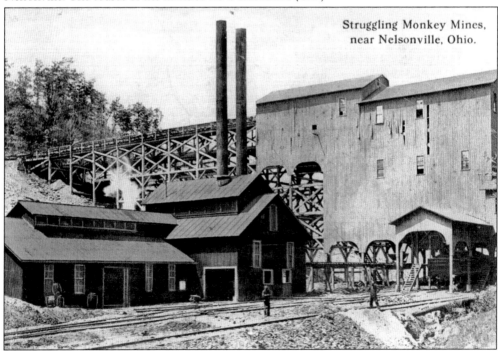

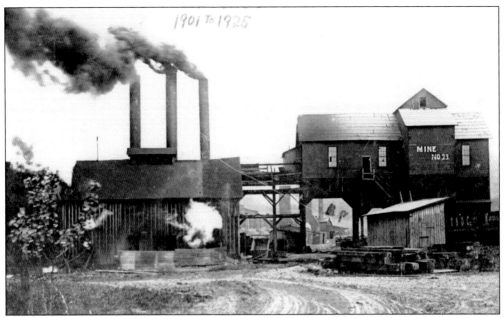

The Hisylvania Coal Company's mine No. 23 was at Trimble, along the K&M railroad line south of Glouster. While the tipple in this view is a standard timber frame structure, the same company's nearby mine No. 22 had a brick and concrete frame tipple, one of only a few such structures. Mine No. 23 was a slope mine that employed 150 men and operated from 1901 to 1925. (OU.)

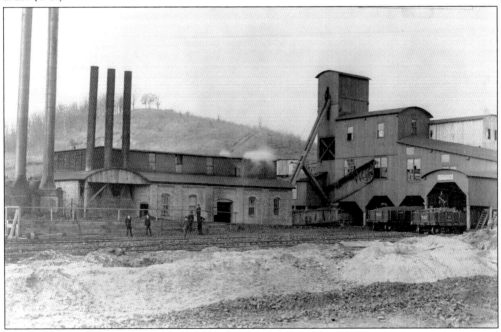

At Chauncey, in Dover Township, Athens County, mine No. 25 was a substantial operation run by the New York Coal Company. It had previously been the Sunday Creek Coal Company's mine No. 275. Its shaft was 125 feet deep, and the mine ran until 1952. This view is from around 1910. Loaded gondolas of the T&OC are at right. (OU.)

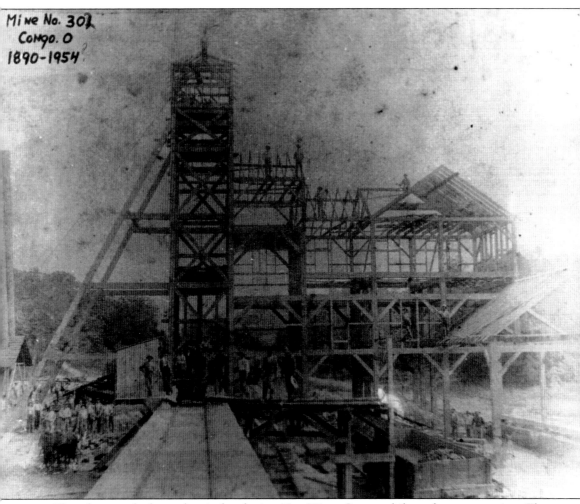

This photograph shows the tipple of mine No. 301 at Congo while under construction. The heavy wood timber framing is similar to barn framing, with substantial posts and beams and many angled braces. The tall head house and angled hoisting frame indicate a shaft mine. The tipple's frame had to carry its own dead weight, as well as the weight of conveyors, coal-cleaning equipment, screens for sorting coal by size, and then the weight of the coal itself, not to mention waste rock separated from the coal. This mine was long-lived, opening in 1890 and shutting down in 1954. (WED.)

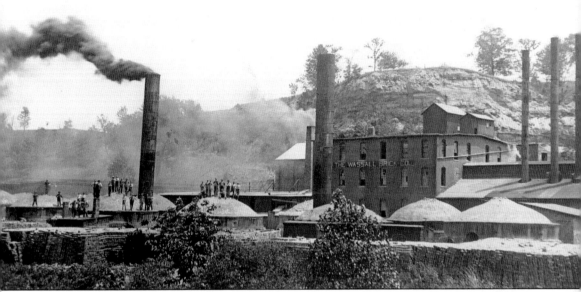

Glouster O. Brick Plant
1895-1932

The clay products industry remained a major employer even as the coal industry dominated life in the Little Cities region. At Glouster was the large plant of the Wassall Brick Company, which produced paving bricks. Here work crews pose atop the domed, or beehive, kilns common in the area's clay products plants. This plant operated from 1895 to 1932, succumbing to the Depression and the change from brick to concrete as a preferred highway paving material. Wassall bricks can still be found on streets in various parts of Ohio. (OU.)

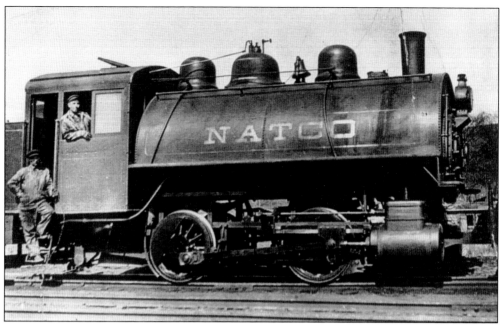

The clay products plant of the Haydenville Mining and Manufacturing Company (see pages 48 through 50), and also the company-owned town of Haydenville itself, was acquired by the National Fireproofing Company (known as Natco) in 1906. Operation of the plant continued until its demolition in 1961, and the town remained company-owned until 1964, gaining fame as the last company town in Ohio. In the photograph above, a Natco switch engine pauses from its duties shuffling freight cars around the plant. In the photograph below, a Natco crew poses with one of the cars that carried clay or shale from nearby deposits to the plant. (HPC.)

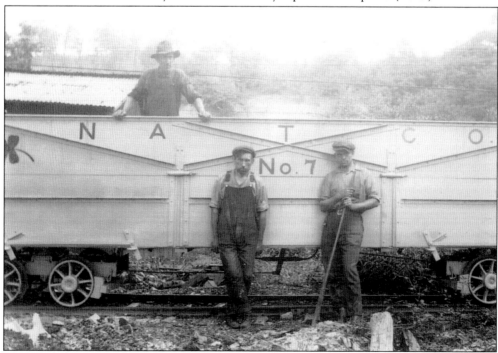

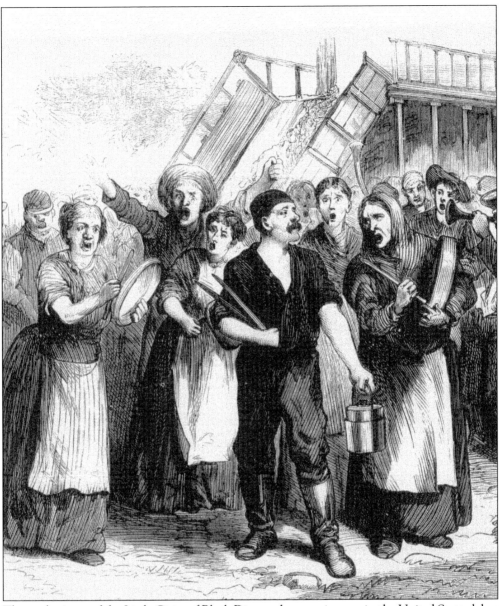

The coal miners of the Little Cities of Black Diamonds were pioneers in the United States labor movement. In 1859, a group of 150 Nelsonville miners called the first recorded strike due to a wage reduction. The nationwide panic of 1873 spawned more disputes and strikes, aggravated by the first use of African American strikebreakers in 1874. Vagaries of the coal market led to other disputes over wages and working conditions. Christopher Evans came to New Straitsville in 1875 and told local miners about efforts elsewhere to organize miners and industrial workers. Meeting with a favorable response, Evans moved to New Straitsville in 1877 and, with other labor leaders, was on the front lines of unionization in the Hocking Valley. The most violent period was the Hocking Valley coal strike of 1884–1885, resulting in the setting of the New Straitsville mine fire that still burns today. High emotion and the threat of violence were always present during these disputes, but the labor organizers' efforts ultimately resulted in formation of the United Mine Workers of America in Columbus in 1890. (LCBDA.)

No. 366

GRAND DRAWING

— FOR THE BENEFIT OF THE —

Knights of Labor of New Straitsville, Ohio.

THE FOLLOWING ARTICLES WILL BE DRAWN:

ONE GOLD RING. ONE TEA SET.
ONE GOLD WATCH. ONE BED LOUNGE.
ONE SILVER CASTOR. ONE BARREL FLOUR.
ONE HANGING LAMP. ONE ROCKING CHAIR.
SIX KITCHEN CHAIRS. LADIES GOLD NECKLACE

TICKETS, 50 CENTS.

TO BE DRAWN JULY 4th, 1888.

Labor disputes could be about working hours or conditions, but more often than not they were over money. Before acceptance of unions became widespread, striking miners were at a financial disadvantage due to lack of income during strikes, a problem at least partially solved by establishment of union strike funds. This 1888 raffle ticket, which offers an interesting variety of prizes, was part of fund-raising efforts for the Knights of Labor assembly in New Straitsville. (NSHG.)

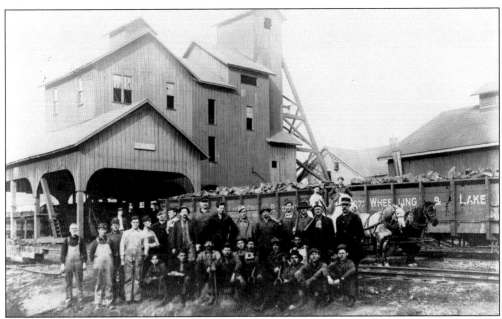

Other than in the photograph of Rendville's main street (see page 62), photographs from the Little Cities region seldom include African Americans. Mine owners' use of black miners as strikebreakers led to a general animosity toward them, and there was considerable prejudice and discrimination that took a long time to fade. William P. Rend, Rendville's founder, was a maverick mine owner, however, who tended to side with miners in labor disputes and who gave African American miners pay equal to that of whites, refusing to use the black miners as strikebreakers. Eventually the town of Rendville gained a primarily black population. However, in the many group photographs taken at mines in the late 19th century, of which the two here are typical, there simply are no African Americans to be seen. That would change over time. (OU.)

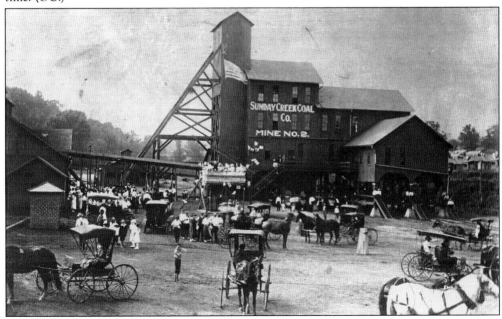

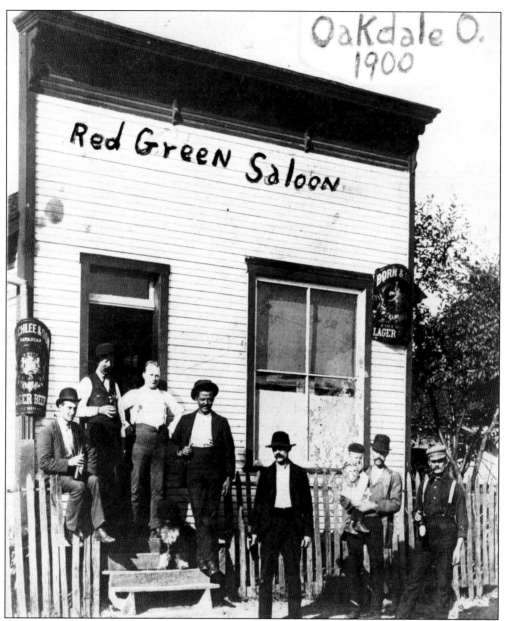

Life in the Little Cities, of course, was not all work. There was time for recreation and fun, some of it as simple as heading to the nearest saloon. This one, a modest place that would feel at home in any cowboy western, was in Oakdale, north of Glouster in Trimble Township, Athens County. It is unfortunate that someone wrote the establishment's name directly on the photograph, but it still provides a sense of daily life in coal country in 1900. Perhaps the assembled gentlemen are celebrating the end of the 19th century, an event that would occur later that year. The advertising signs were distributed to customers by the Schlee and Born Breweries, two of the major German breweries in Columbus in the era before Prohibition. (OU.)

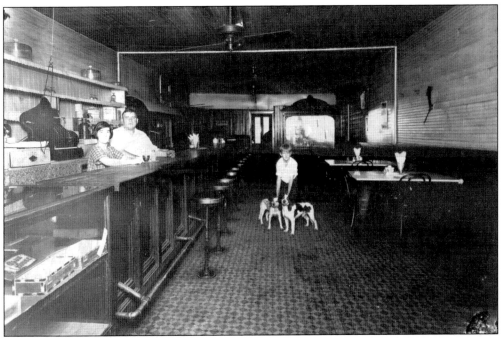

A meal at a local restaurant was another diversion during time off work. Shorty Young's restaurant in New Straitsville is in the undated photograph above; Club House cigars are offered in the case at left. The photograph below is also undated and the location not noted, but it is presumed to be a New Straitsville saloon. It is elegant indeed, with its carved wood bar, pressed-metal walls and ceiling, electric lights, and framed artwork, not to mention strategically located spittoons. The photographer had to use flash powder to light the scene, which may explain why everyone stood well back from the camera. (NSHG.)

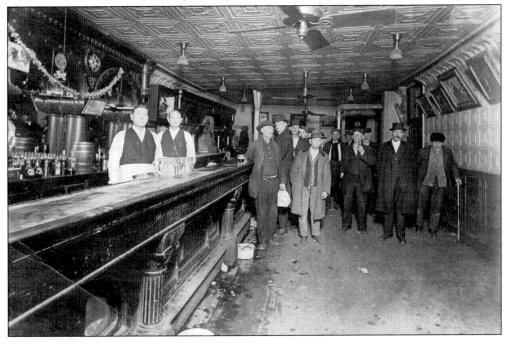

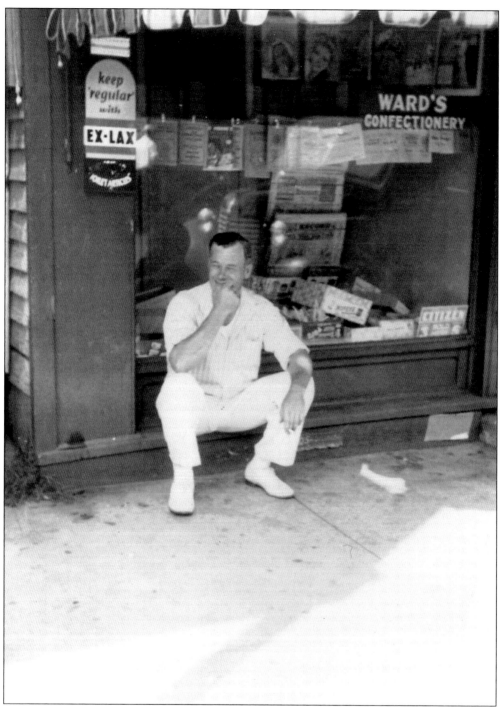

Ward's Confectionery was a staple of life in New Straitsville. Here Charles Strain sits on the front step when Ward's was on the north side of the street. It later moved to the south side and today still operates as a restaurant, adjacent to the New Straitsville History Museum. Advertising a laxative so prominently on the storefront may have discouraged some business. (NSHG.)

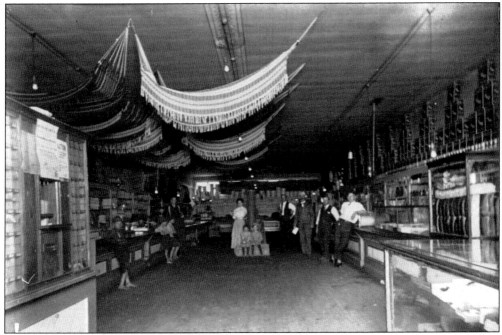

Shopping in the Little Cities a century ago was more for buying necessities than for entertainment, but it still was a chance to get out, see people, and catch up on the local news. The photograph above was made at the Sunday Creek Coal Company store in Congo, where children, shoppers, and store clerks have stopped for a photograph. It must be summer, since the boys at left are barefoot. The two girls sitting in the middle also are shoeless but are appropriately stocking-clad. Note the large number of hammocks for sale, displayed on the ceiling. The lower view is the W. W. Jones store in Shawnee, where Jones himself, on the left, is advising a customer about a purchase. (Above, WED; below, LCBDA.)

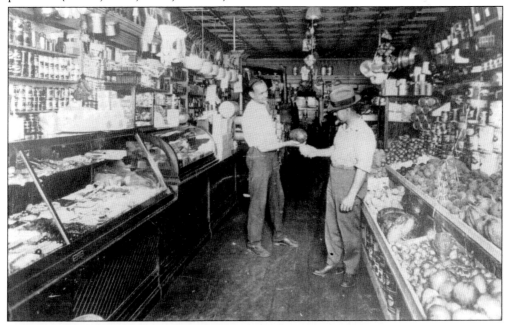

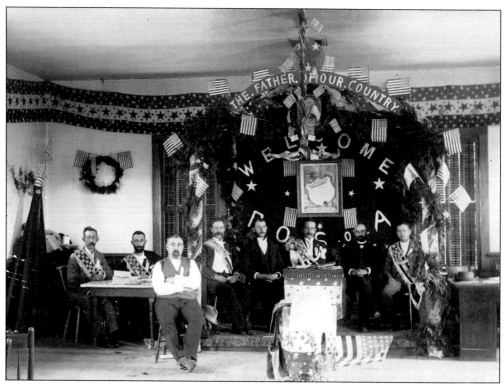

Social, patriotic, ethnic, and service organizations were a large part of the social life of a community in the days before radio and television started to keep people at home in the evening. In this late-1880s view, the proud members of the Patriotic Sons of America pose in their meeting hall in the Improved Order of Red Men's building in Hemlock. (WED.)

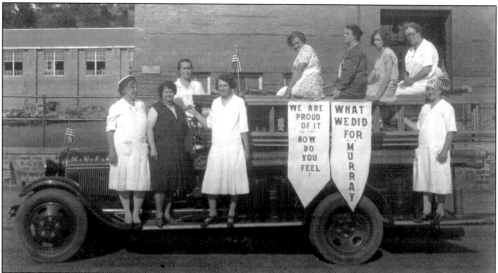

Public projects were another aspect of Little Cities life. This group of women, working without any official organization, raised enough money to purchase a new fire truck for Murray City. On July 4, 1930, they pose proudly with it, along with a banner nudging their fellow citizens to give and do more for the community. (JS.)

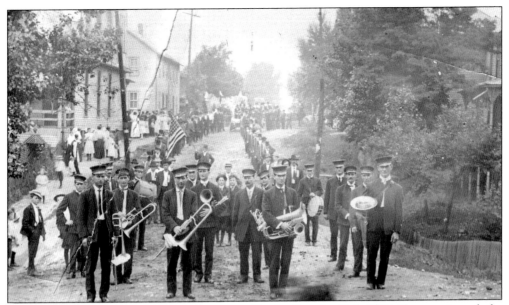

Warm weather encouraged outdoor diversions. On the Fourth of July 1910, Shawnee is ready for its annual parade. Paved streets had not yet arrived, and it appears the photographer could not persuade the dog in the foreground to stand still for the long exposure. (LCBDA.)

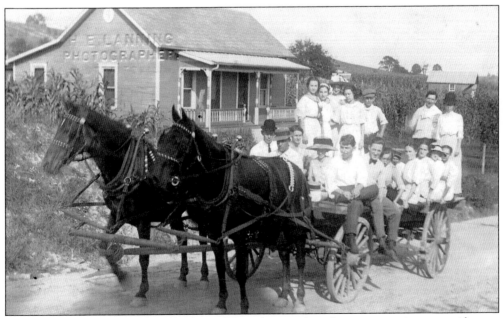

There is nothing on this photograph to suggest date or place, but an open-air wagon ride on a sunny day was a pleasant way to pass some hours. (NSHG.)

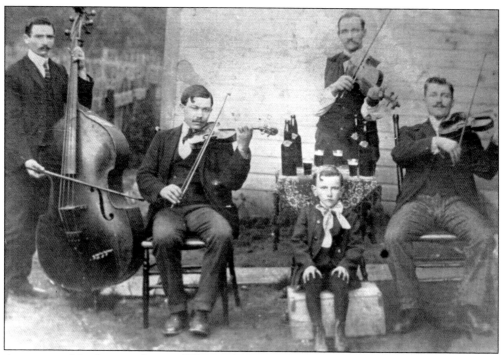

A note on this photograph says, "This is Hungarian Band from Congo." Outdoor concerts also were part of Little Cities life, and this mustachioed quartet, fortified by bottles of liquid inspiration, is ready to play. The serious little boy, son of one of the musicians, looks as though he would rather be elsewhere. (WED.)

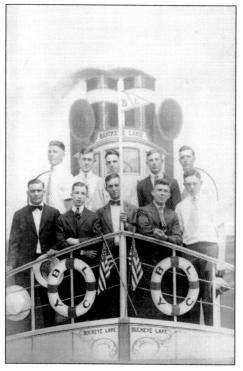

A short ride up the B&O line from Shawnee took recreation seekers to Buckeye Lake. Located at the far northwestern corner of Perry County, the lake was a former canal reservoir that became a vacation destination, especially after interurban service from Columbus and Zanesville became available. These visitors from the Little Cities region pose for their portrait at the lake. (LCBDA.)

Organized indoor entertainment took many forms. These tickets represent just some of the options available many years ago. The Indian Theatre was on the second floor of the Improved Order of Red Men building in Shawnee. Known today as the Tecumseh Theater, it survives today; see page 125. The mimeographed basketball tournament ticket is a reminder of the importance of school sports as part of a community's life. (Above, NSHG; below, WED.)

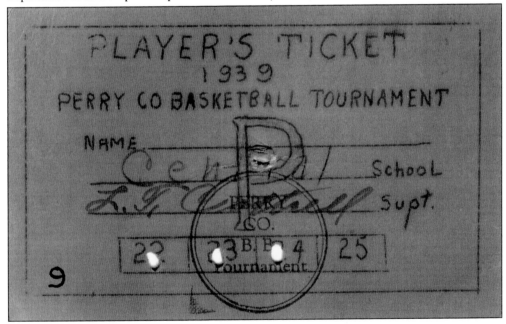

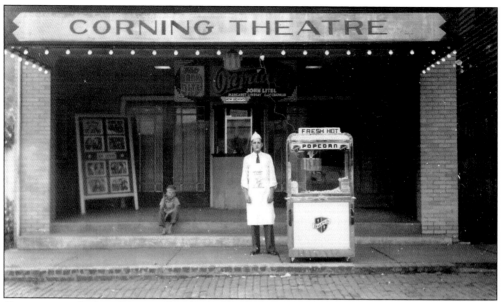

Corning, too, had a theater. Like the Linda in Shawnee, it offered moving picture shows. A properly uniformed Bob Conley made sure patrons had plenty of fresh, hot popcorn. (WED.)

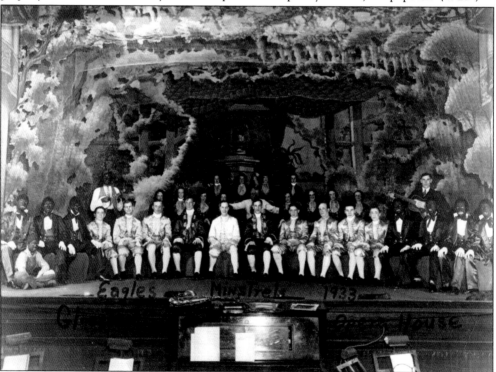

As offensive as people find them today, minstrel shows were a staple of early-20th-century life. These are the Eagles Minstrels, ready for a 1933 performance at the Glouster Opera House. Elaborate painted scenery flats and fancy costuming were standard, along with performers in blackface. Note the piano and music stands in the orchestra pit—no recorded music here. (OU.)

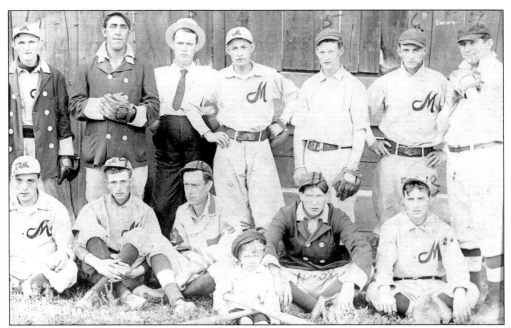

As summer waned and fall approached, both the adults' and the kids' baseball teams got in their last few games. In the photograph above, date unknown but possibly about 1910, the Murray City Tigers are ready to take the field. Their batboy seems young, so perhaps the little fellow is more like a mascot. In the view below, the Glouster kids' team of 1910 appears at least as confident and skilled as the men from Murray City. High lace-up shoes, dark stockings, and soft caps are all part of the uniform. (Above, JS; below, OU.)

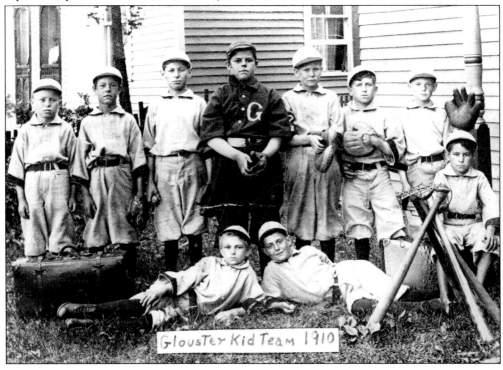

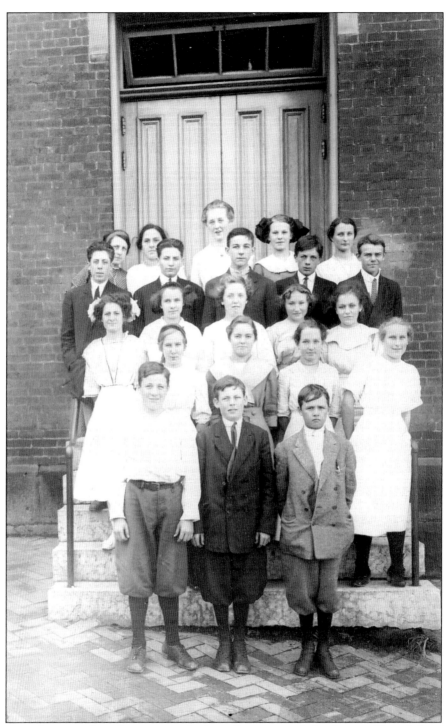

Fall meant the start of another in a seemingly endless string of school years. One of the rituals, requiring proper attire, was the annual class picture. This is probably from the late 19th century, but the school and the location are not noted. At least it meant a few precious minutes outdoors and away from studies. (LCBDA.)

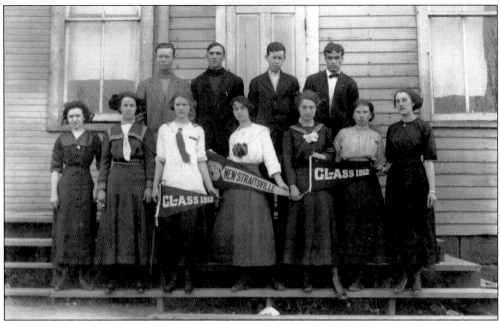

In another class picture, this time of the New Straitsville school's class of 1912, 11 serious scholars pose in the photograph above (although it is possible the woman at the right is in fact the teacher). In the photograph below, around 1930, the nearly smiling students of the Congo school, more informally dressed, briefly sit still on the school steps for the photographer. Year after year, young people completed their education in the schools of the Little Cities, a few possibly going on to college or trade school but most ready to seek work. However, by 1930, the celebrated Hocking Valley coal boom had ended, depression and war lay ahead, and life in the hills would be changed forever. (Above, NSHG; below WED.)

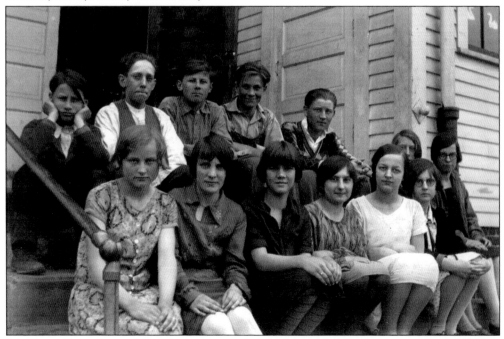

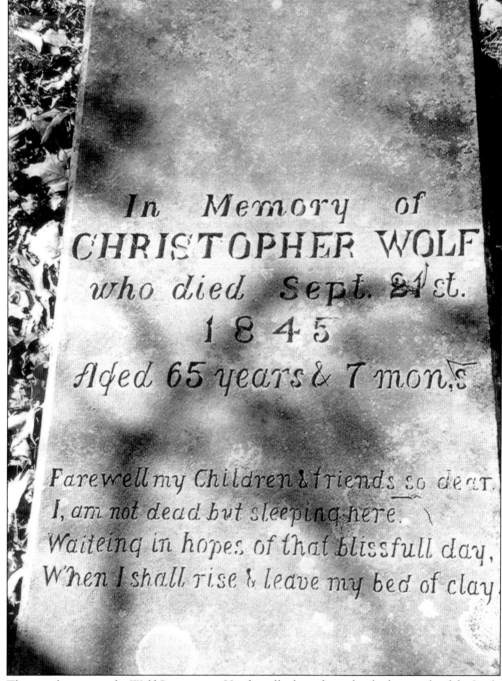

This simple stone in the Wolf Cemetery at Haydenville shows how closely the people of the Little Cities of Black Diamonds were tied to the land on which they lived and worked. Christopher Wolf died in 1845, well before the coal boom period, but his epitaph, errors and all, could apply to any number of people from the region: "Farewell my Children & friends so dear, I, am not dead but sleeping here. Waiteing in hopes of that blissfull day, When I shall rise & leave my bed of clay." (HPC.)

Five

AFTER THE COAL BOOM

In the period immediately after World War I, a variety of factors combined to bring an end to the 50-year boom that had meant general prosperity for the Little Cities of Black Diamonds. Coal production had risen dramatically to meet the fuel demands of the war (Perry County alone, for example, went from 1.2 million tons in 1916 to 3.5 million in 1918), but the end of hostilities meant a rapid slump in demand and price. In addition, development of mining technology enabled large mechanized mines to open in West Virginia and Kentucky and gave them a cost advantage over the Ohio mines. At the same time, the Interstate Commerce Commission forced the railroads to reduce rates from these newer mines to shipping ports such as Cleveland; this erased the geographic advantage once enjoyed by the Little Cities mines. All these disruptive influences led to a nationwide coal strike in 1922, and then in 1924, the United Mine Workers of America agreed to a wage rate of $7.50 a day, too much to permit the small and antiquated Hocking Valley mines to operate profitably, so mine after mine ceased production. Then the Great Depression drove even more operators out of business. Coal production revived during World War II, but an increasing proportion came from surface mining, which was less labor intensive than underground mining, so employment in mining never recovered to former levels.

Economic decline in the Little Cities was not immediate; it was more like a slow downward drift as fewer employment opportunities forced young people to move away to seek work. Stagnant or declining populations caused many familiar local businesses to close, while fires and neglect began to claim some of the region's distinctive architecture. One positive event was the federal purchase of former coal lands in the 1930s and 1940s in what became the Wayne National Forest. The U.S. Forest Service immediately began efforts to replant forests, halt erosion, and rehabilitate exhausted farmland.

The picture would brighten significantly in the mid-1970s, but the 50-year bust that followed the 50-year boom was a difficult period. The future of the Little Cities of Black Diamonds was in serious doubt until a new pioneer era began.

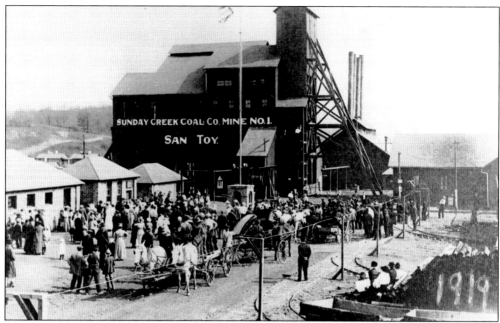

Sunday Creek's mine No. 1 at the company town of San Toy, which straddled the Morgan and Perry county line, illustrates the abrupt turn in the fortunes of the Little Cities region that took place between World War I and the mid-1920s. The photograph above was made in 1919, when the mine was still producing and dozens of people had gathered for some now-unremembered event. The photograph below shows the mine from the opposite direction and was made in May 1927. All looks normal until one notes the lack of people and the rows of idle mine cars. Production had ceased, the tipple burned later that year, and San Toy's reason for living was gone. (Above, OU; below, authors' collection.)

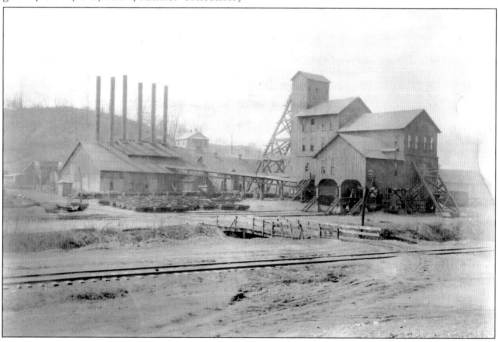

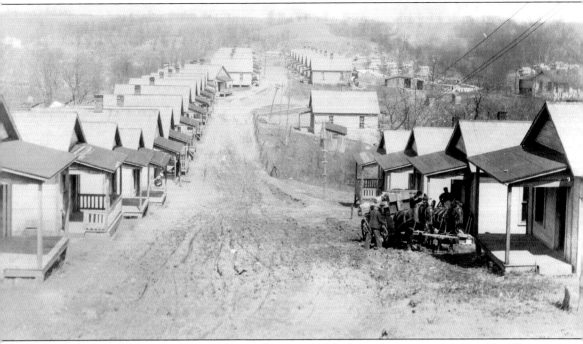

About a month before the lower photograph on page 96, this was the scene in San Toy. On the back of this photograph is a caption: "Main street of San Toy, Ohio showing one of the several long rows of empty houses. In the picture can be seen one of the few remaining families moving from the deserted village." Poor San Toy did not even survive long enough to enjoy paved streets, although it enjoyed brief fame as the location of Perry County's first and only hospital. (Authors' collection.)

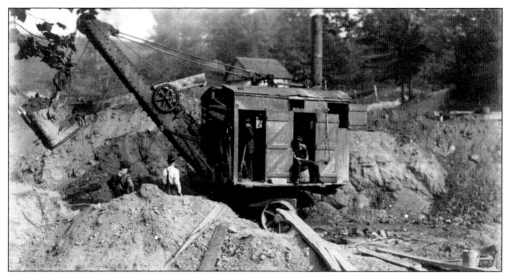

There was no surface or strip mining in Perry or Athens Counties until late in World War I and none in Hocking County until 1925. As excavation technology developed and equipment grew larger, surface-mined coal claimed a greater and greater proportion of the region's production. The steam-powered shovel in the photograph above, at work in South Hemlock, was a forerunner of the massive excavators still to come. Underground mining, with its greater technical difficulty, larger employment, and higher costs, began to lose ground. Even so, some mines, such as shaft mine No. 301 at Congo, continued to operate. Although long abandoned by the time the photograph below was taken, this mine had a long career, from 1890 to 1954. (WED.)

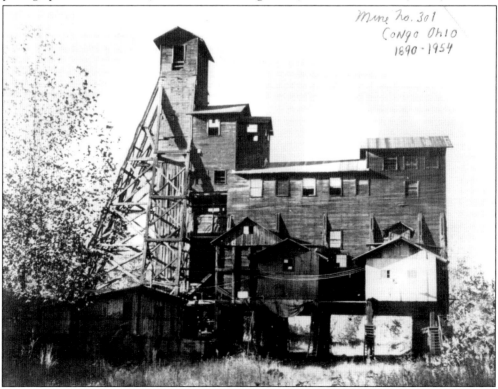

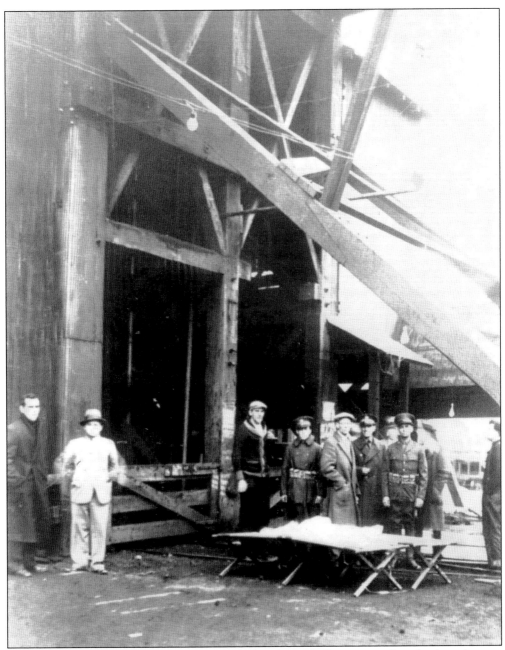

The beginning of the Depression era was marked in the Little Cities region by a shocking disaster. On November 5, 1930, the Sunday Creek Coal Company's mine No. 6 was rocked by a massive explosion. Nine hours later, rescuers found 19 people still alive three miles from the main shaft, but 82 others were lost, including, ironically, company executives visiting the mine to inspect new safety equipment. The mine was at Millfield, off today's State Route 13 a little north of Chauncey. On January 3, 2009, Sigmund Kozma, the last survivor of the blast, passed away; he had been 16 years old on that sad day. Today only some rubble remains at the site of mine No. 6, but a memorial plaque commemorates Ohio's worst coal-mining disaster. In this view near the shaft, rescuers await bodies of the victims. (PM.)

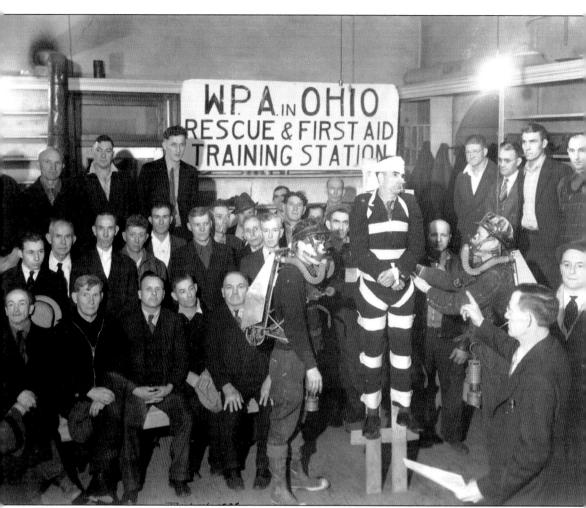

During the Depression, federal funds through the Works Progress Administration (WPA) paid for parks, bridges, artwork, and dozens of other undertakings intended to put unemployed people to work while creating lasting public investment. With the memory of the Millfield disaster still fresh, the WPA sponsored mine safety training in the Little Cities region. Here is one such session, featuring a cooperative "victim" and rescuers equipped with breathing apparatus that enabled them to work in mines filled with poisonous gases. (NSHG.)

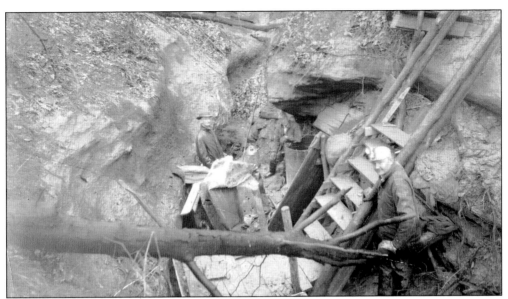

Coal, clay, oil, and gas were not the only products that came out of the hills of the Little Cities region. The locals were quite skilled at making white lightning too. Moonshine stills were fairly common, as were the federal and state revenuers (revenue agents) whose job was to root them out. In a constant game, moonshiners hid stills and agents found and destroyed them. The photograph above, taken in 1932, says, "Showing how difficult it was to get down to some of the hidden stills. After officers had scaled down this 200 foot ledge it was necessary to build a ladder to get back out with their still as evidence." Below, the moonshiners work in the shelter of either an abandoned mine or a natural cave. New Straitsville's annual Moonshine Festival grew out of this long-lived tradition of local beverage production. (NSHG.)

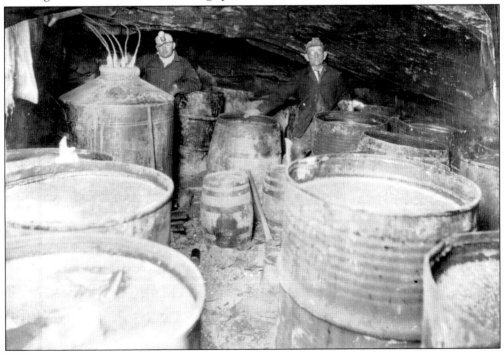

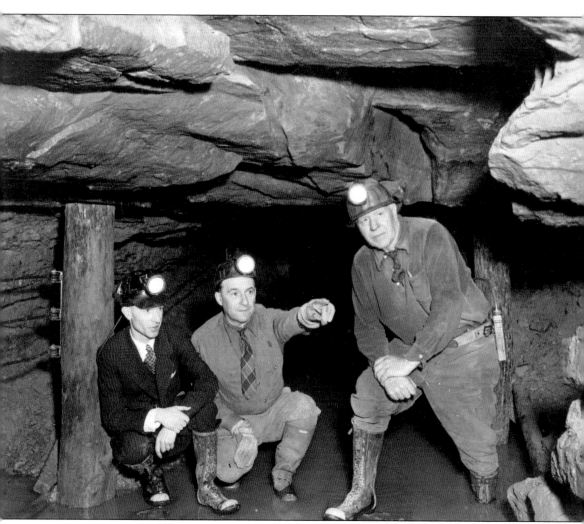

When miners rolled blazing mine cars into five different mines at New Straitsville during the great Hocking Valley coal strike in 1884, they had no idea of how long their work would last. Ironically, the arsonists were not on strike, but they resented closure of the mines and apparently decided that if they could not work, no one could. The coal seams have been burning ever since, and even today smoke and gases will crop out when the coal burns out and subsidence causes a fissure to open in the soil. One of the better-remembered WPA projects was an unsuccessful effort to extinguish the fire. The caption on the back of this photograph notes, "Ernie Pyle, Scripps-Howard's celebrated peripatetic columnist, inspecting the progress of WPA workers in the Lost Run Tunnel of the New Straitsville Coal Mine Fire Project. Left to right: Mr. Pyle, Mr. Cavanaugh, Mr. Laverty." Pyle became famous for his photography and reporting from the Pacific theater during World War II, where he was killed in battle. (NSHG.)

The people of the Little Cities were nothing if not resourceful. This map is from a brochure printed around 1938 by Underground Fires, a guide service that promised safe but exciting tours of the New Straitsville mine fire. Four bits got one a tour that included the air shaft on Plummer's Hill, Bob Ripley's broadcasting site (for his *Believe It or Not* radio show), Old Faithful, Devil's Basin, Hell's Oven, and the WPA firefighting project. (NSHG.)

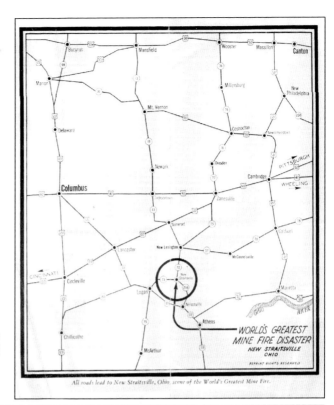

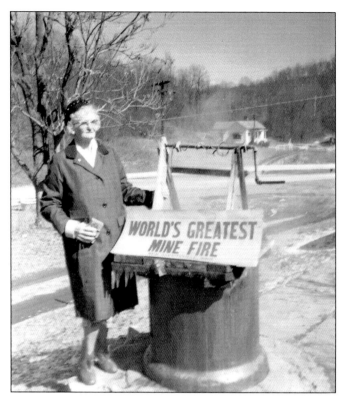

In the photograph at left, taken in the 1960s, Mrs. Owen Wallace poses by the "steaming well" caused by the New Straitsville mine fire. In the photograph below, which dates from 1974, the fire has caused State Route 216 just outside New Straitsville to heave and rupture. According to local people, the fire has since worked its way back into the hills and become much more elusive. (NSHG.)

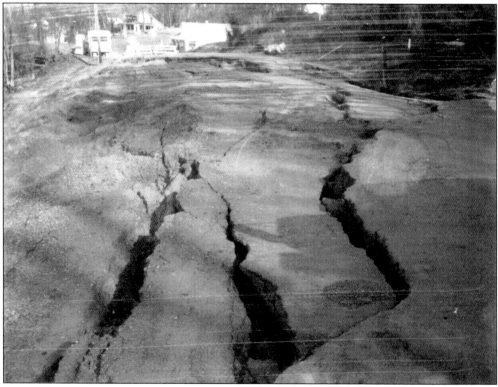

If the coal boom period of the Little Cities' history was mainly a story of resource extraction, then the decades that followed were, at least in part, a story of recovery of the land. The effort actually dates back to 1911, when Congress passed legislation that allowed the federal government to work with state legislatures to create national forests to protect watersheds. The Ohio General Assembly passed legislation in 1934 authorizing such action, and between 1935 and 1942, the U.S. Forest Service acquired 77,000 acres in southeastern Ohio, paying between $4 and $5.50 an acre. The forest service immediately began work to halt erosion, control fires, and restore land to a natural state. In 1951, after purchases had reached 97,000 acres, these lands officially became the Wayne National Forest. As part of its efforts, the forest service built fire watchtowers. This photograph shows the Shawnee lookout station in 1939. It was erected in northern Hocking County, about two miles south of New Straitsville, at an elevation of about 1,000 feet. (LCBDA.)

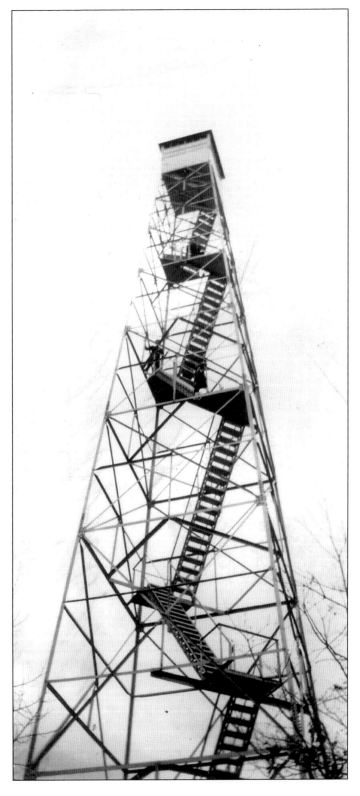

Coal mining has never disappeared entirely from the Little Cities region, but since the end of the boom, it has never provided the same levels of employment as in the past. This made it much less a part of the local economy. The clay products industry today is gone from the region, but it lasted until well past World War II and provided good employment. At New Straitsville, the brick plant, as the locals knew it, in the 1950s still produced chimney flue tile. The photograph above shows an extrusion machine producing a continuous piece of square, hollow, wet clay, while the photograph below shows the same material after cutting to length, drying, and firing in a kiln. (Above, NSHG; below, LCBDA.)

Nelsonville, too, produced clay products. The first of its four brick companies opened in 1871 and closed in 1937, gaining fame as the source of the star brick, used across the country as a paving brick (the surface pattern provided better traction for pedestrians and vehicles). Nelsonville brick won a first prize at the 1904 Louisiana Purchase Exposition in St. Louis, and the Indianapolis Motor Speedway was paved in Nelsonville bricks, giving rise to the track's nickname, "the Brickyard." (NPL.)

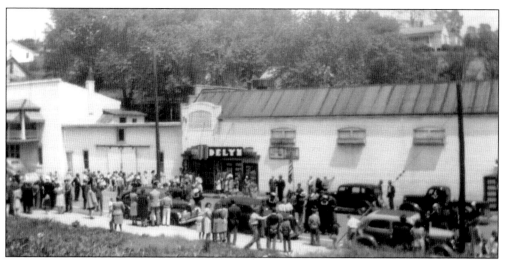

After the boom, life in the Little Cities went on through good times and bad, celebrating holidays and rituals just as in any other cities and villages. The photograph above, from the 1940s, shows New Straitsville's Decoration Day (now Memorial Day) parade. The Delyn Theater building still stands on the east side of State Route 93. In the photograph below, an honor guard has assembled in downtown New Straitsville for a funeral. (NSHG.)

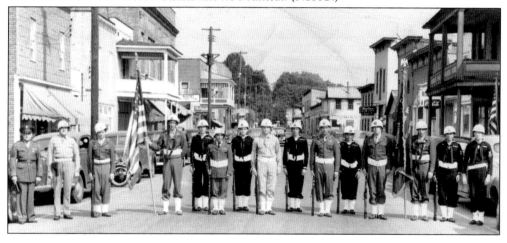

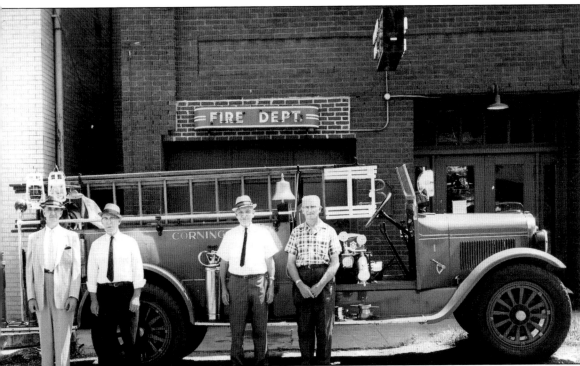

In 1929, the Corning Volunteer Fire Department acquired its first fire truck, a Dodge. The date of this photograph was not recorded, but it is probably from the late 1950s or early 1960s, when, from left to right, Murray Brown, Willis Wright, Clyde Thomas, and Ralph Briggs posed in front of the old town hall with the venerable machine. Corning's fire truck had its finest hour when it worked continuously for a day and two nights fighting a coal tipple fire on State Route 13. (WED.)

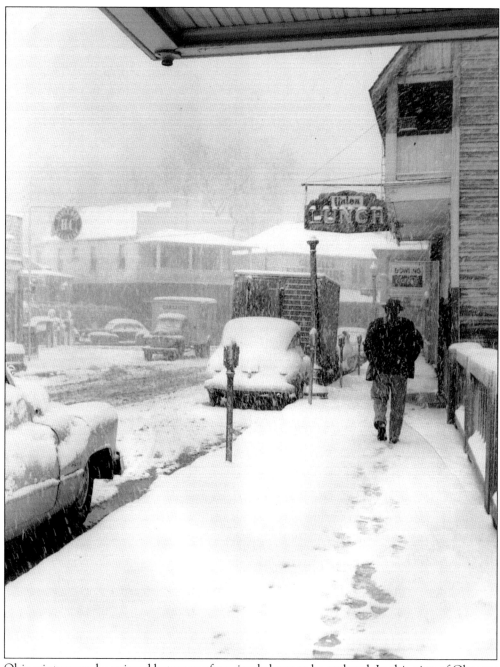

Ohio winters can be enjoyed but more often simply have to be endured. In this view of Glouster in early 1950, the snow continues to fall and is beginning to pile up as people go about their tasks. The view looks north on High Street (State Route 13) around where the street crosses Sunday Creek and turns sharply to the right on the way to Corning. (PM.)

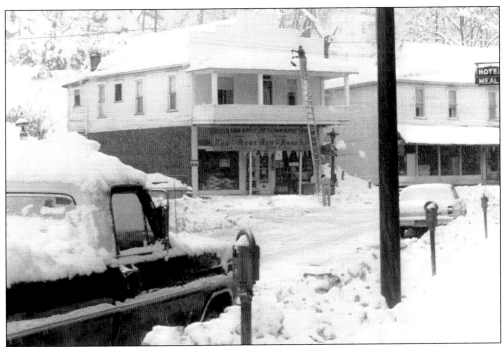

Even more snow has fallen in another view of Glouster in the 1960s. The building from which men appear to be removing snow to reduce the load on the overhanging porch can be seen behind the delivery truck in the photograph on page 110. (PM.)

In 1964, on a much warmer day, this is the northward view along High Street in Glouster. The photographer stood a block or so south of where the two previous photographs were taken. (PM.)

Also shown in the snow, but with melting well underway, downtown New Straitsville is quiet in this view from around the mid-1970s. Wilson Brothers was known for its cheese, which was aged in a cave dug into the hill behind the store. The building in the background, deteriorated and listing to the right, is gone, as is Wilson Brothers, although the store building still stands. (NSHG.)

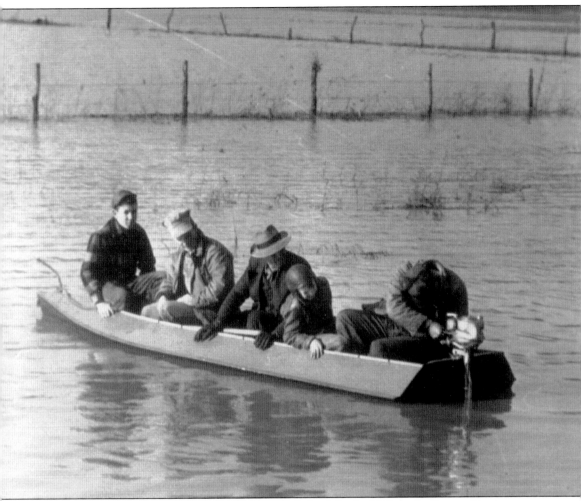

Burr Oak Lake is a flood-control and recreational lake built by the U.S. Army Corps of Engineers. Much of the lake lies in Morgan County, although the Tom Jenkins Dam that created the lake is off State Route 13 a few miles north of Glouster and just south of the Perry County village of Burr Oak. The lake has a comfortable Ohio State Parks lodge, cabins, boat rentals, and other recreational facilities and is a popular and busy place in warm weather. In 1950, the dam has just been completed and the lake has begun to flood the East Branch of Sunday Creek. This photograph is captioned "First Boat on the Lake," but the boat's passengers seem to be struggling with an outboard motor that refuses to start. Note the fence lines in the background, still marking farm fields that would soon disappear forever under the lake's waters. (PM.)

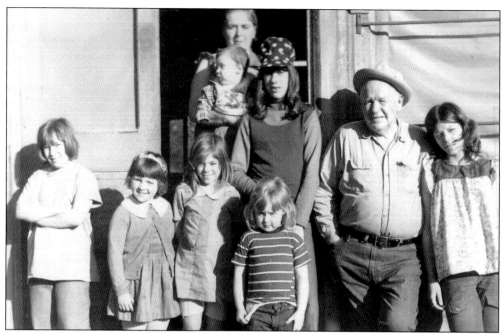

This photograph, titled "Pool Hall Gang, 1973," shows Wes Tharp Sr. at right center. Wes Jr. wrote that his father put the pool table in the former post office building in Hemlock. During the day, Wes Sr. let the local kids play. The slate-topped table was so heavy that railroad ties had to be put under the floor of the building to support it. (WED.)

As time went on, major Haydenville buildings were demolished, along with all but one of the round houses and several homes. Today the deteriorated Hocking Valley Railroad station is endangered, but the town remains remarkably intact, and its church soldiers on, showing off its multitude of brick colors and textures. An excellent museum housed in a former company house is run by the Haydenville Preservation Committee. (HPC.)

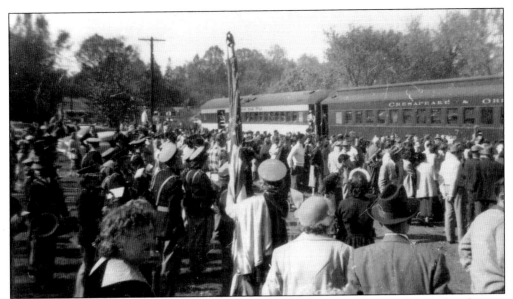

Changes in the period after World War II included abandonment of most of the railroad routes serving the Little Cities. In 1952, the C&O ran an excursion to New Straitsville on the former Hocking Valley Railroad line. This was the last passenger train the town would see, although freight service continued for some time. (NSHG.)

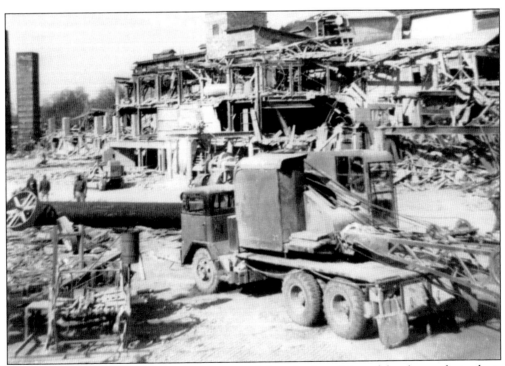

A major blow to Haydenville was the closing and then the demolition of the clay products plant, which took place in 1961. (HPC.)

One of the saddest stories of the Little Cities tells of King the school dog. A stray brown and white collie taken in by a teacher in the New Straitsville school, King was a fixture at the school for 10 years. He was present in the first-grade classroom every school day. Each year he greeted the new first graders, comforting children who were frightened or unsettled on their first day. He played outside at recess, visited children's homes on weekends, and spent the summer with various families. Then, two days before Christmas in 1964, the local newspaper reported King missing and noted how sad Christmas would be for local families if he could not be found. He was never seen again. (NSHG.)

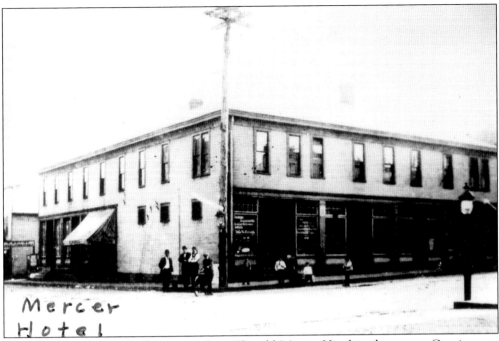

Fire has struck the Little Cities too often. The old Mercer Hotel in downtown Corning was a fixture for decades. It became the Sunday Creek store No. 109 in 1908 and later Siemer's Store. The photograph above shows the building in its hotel days and the image below after its destruction by fire in 1979. The Mercer Hotel was the site, in the 1890s, of the first violation of Ohio's antidiscrimination law. The hotel refused to seat Richard L. Davis of Rendville for a lunch meeting of District 6 of the United Mine Workers of America. A delegation from West Virginia had objected to Davis's presence. When he was denied seating, the Ohio delegation walked out, and the hotel was fined for breaking the law. (WED.)

Although somber in character, this photograph really is an image of endurance and perseverance. Carefully molded and hand-inscribed in 1884, it shows one of the distinctive ceramic headstones in the Haydenville Cemetery. It has endured for nearly 130 cold winters and 130 hot summers; the sun is bright and the grass is green. It is possible this artifact from the past tells visitors something about the spirit and the character of the Little Cities of Black Diamonds and the people who live there. (HPC.)

Six

The Little Cities of Black Diamonds Today

Earlier chapters explored the rich heritage of the Little Cities of Black Diamonds. Today that heritage is a strong economic force, helping to rebuild communities, increase awareness of and pride in the region's story, strengthen employment opportunities, and bring new visitors and residents to the area.

With heritage and civic tourism on the rise nationally, the Little Cities are ideally positioned to take advantage of current trends. National studies have shown that heritage tourists want to visit authentic places with a real history and a real story to tell. The Little Cities of Black Diamonds have this and more, offering not only an intriguing history and distinctive architecture but also a landscape full of recreational opportunities such as hiking, biking, and boating. The region is especially attractive to visitors from the ever-growing Columbus metropolitan area, as well as more distant points, from which short weekend trips can easily be made.

Heritage development efforts go back to the mid-1970s, when a determined group purchased the Tecumseh Theater building in Shawnee to keep it from being demolished. Projects since then include the purchase and restoration of Robinson's Cave in New Straitsville, the opening of historical museums in Haydenville and New Straitsville, creation of a privately owned mining museum in Shawnee, and the painting of history-themed murals in public places. Local organizations have secured outside funding for planning, building restoration, and youth programs. Annual festivals and tours celebrate the region's historical, architectural, cultural, and arts heritage. Other groups are helping to reduce pollution from acid mine drainage; others are actively gathering historic photographs, documents, and artifacts to keep them from being lost, including a 4,000-name miners' registry.

This region's modern story is one of rebirth and new growth. Much has been accomplished, but there is more to do. A trip to the Little Cities of Black Diamonds will show the visitor why there is so much to celebrate but also why there is little time to rest.

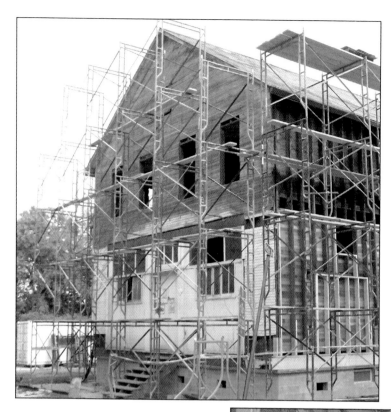

The coal company store, once a fixture of the Little Cities, has disappeared almost entirely. Private owners have undertaken a careful restoration of the store in Eclipse. Originally called Hocking, the community has taken the name of the mine it formerly served. Eclipse is located off U.S. Route 33 south of The Plains in Athens County, adjacent to the former Hocking Valley Railroad right-of-way. (CR.)

The downtown square in Nelsonville is surrounded by well-kept commercial buildings. Historic Stuart's Opera House, which has a full calendar of shows, performances, and events year-round, is a major draw, but there also are restaurants, shops, and art galleries. Together with the Rocky Boots outlet and the Hocking Valley Scenic Railway, Nelsonville offers many reasons to stop off U.S. Route 33 for a day's visit. (LCBDA.)

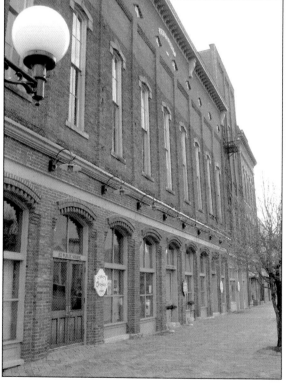

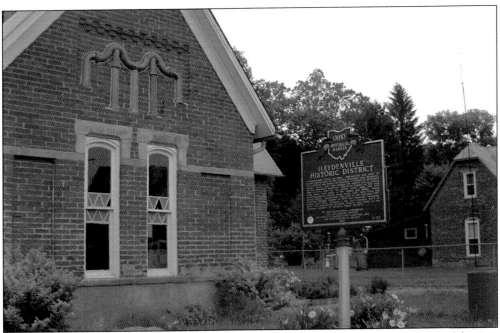
One of the distinctive brick company houses in Haydenville has become a museum celebrating the community's history. Note the sewer tile ornamentation in the wall of the house, an example of how almost everything in town was built out of the clay products from the plant begun by Peter Hayden more than a century and a half ago. (LCBDA.)

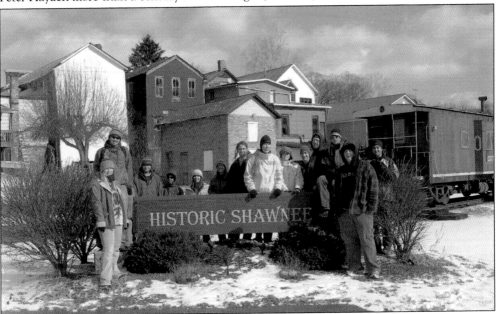
Students from Hocking College in Nelsonville gather on the former railroad right-of-way behind Main Street in Shawnee during a study of the historic Little Cities community. This is just one example of programs begun by local individuals and nonprofit organizations to teach young people about both the region's heritage and developing skills needed in school and in the workforce. (LCBDA.)

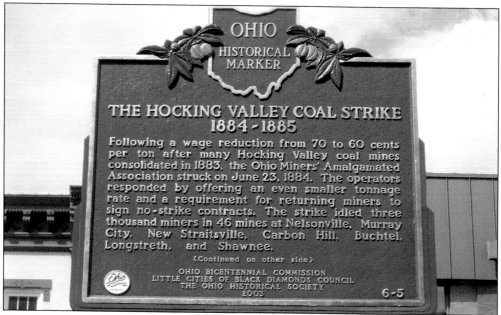

Historic markers help tell the story of the Little Cities in several of the region's communities, providing a context to help visitors understand the historical events that shaped the life and look of the various cities and villages. New Straitsville has an excellent museum that tells even more of the coal-mining story, including a "coal mine" in the basement, designed and built by a local high school student. (LCBDA.)

The former school in Corning is now the Corning Civic Center. It sits atop a hill overlooking the community and is the center of many events and activities. Even with limited resources, local individuals and groups have been able to preserve many significant landmarks that help tell the story of the region. (LCBDA.)

At the beginning of the path to Robinson's Cave is Dunkle Hall, used for community meetings and owned by the New Straitsville History Group. A recycled campground building from another location, it is named for one of the community's best-known citizens. Hubert Dunkle in recent years became known as the "Can Man" for his untiring efforts gathering empty aluminum cans to raise funds for acquisition and restoration of Robinson's Cave. Dunkle would go anywhere to pick up cans people had saved; another option was simply to throw them into the small front yard of his home. His motto was "When nothing else can, cans can." Having raised well over $10,000 from gathering more than a million cans, Dunkle saw his goal achieved. (LCBDA.)

Since well before World War II, the Wayne National Forest has worked to restore damaged land and encourage the return of the forest that once covered the hills and valleys of the Little Cities region. The Wayne National Forest headquarters building, along the east side of U.S. Route 33 between Nelsonville and Athens, was inspired by the region's coal mine tipples and has historical displays, trail information, a gift shop, and restrooms. (WNF.)

One of the efforts undertaken by the U.S. Forest Service was construction of fire towers to protect against forest fires. This is a view of the Shawnee tower near New Straitsville. The forest cover has become so dense since restoration efforts began around 70 years ago that it is hard to believe the land in this region was once as bare and open as it appears in many historic photographs. (LCBDA.)

Although it has lost most of its plaster to moisture damage, Shawnee's Tecumseh Theater in the former Improved Order of Red Men building is remarkably intact. Returning the theater to its historic use is a long-term goal of local citizens. (LCBDA.)

The Little Cities region hosts four seasons of activities, recreation, and travel experiences. Summer naturally tends to be the busiest time, but even in winter there is much to see and do. One advantage of the area is its closeness to the popular Hocking Hills region just to the north along U.S. Route 33. (LCBDA.)

Locally produced publications celebrate both the human and the natural heritage of the Little Cities region. Available in local gift shops, galleries, and museums, these books, as well as organized tours and regular events, have helped to make heritage an important part of the area's economic base. (LCBDA.)

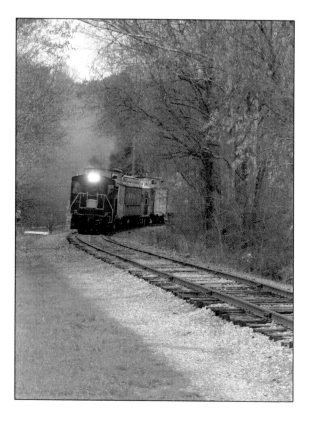

The Hocking Valley Scenic Railway runs on the tracks of the original Hocking Valley Railroad, which reached the Little Cities region from Columbus in 1869. From its modern depot in downtown Nelsonville, the scenic railway runs regular excursions to Logan and back and offers special seasonal runs such as Santa Claus trains. (AB.)

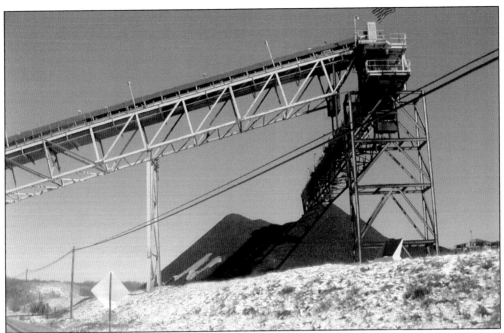

The coal boom has come and gone, but the coal has not. Some mines have recently opened in the Little Cities region, helping to strengthen the employment base. Modern mining methods are considerably less damaging and friendlier to the environment than those employed in the boom period. (LCBDA.)

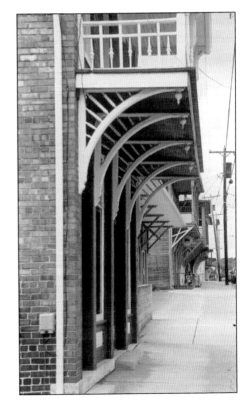

The village of Shawnee still has the character of a coal boomtown. It has a large number of intact overhanging porches, and the community has a powerful sense of time and place. It is one of several excellent starting points for anyone curious to experience the unique heritage of the Little Cities of Black Diamonds. (NAR.)

Discover Thousands of Local History Books Featuring Millions of Vintage Images

Arcadia Publishing, the leading local history publisher in the United States, is committed to making history accessible and meaningful through publishing books that celebrate and preserve the heritage of America's people and places.

Find more books like this at
www.arcadiapublishing.com

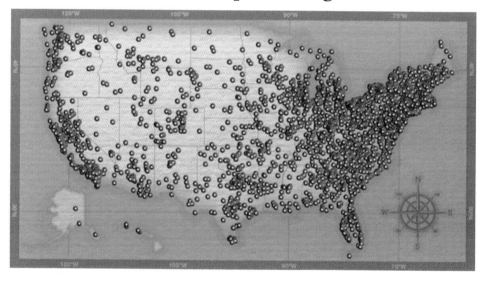

Search for your hometown history, your old stomping grounds, and even your favorite sports team.

Consistent with our mission to preserve history on a local level, this book was printed in South Carolina on American-made paper and manufactured entirely in the United States. Products carrying the accredited Forest Stewardship Council (FSC) label are printed on 100 percent FSC-certified paper.